IMAGES
of America

LAKE ORION

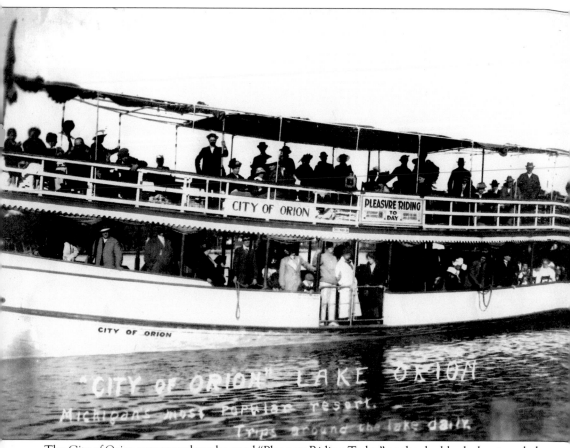

The *City of Orion* passenger boat boasted "Pleasure Riding Today" as the double-decker traveled the lake providing scenic views and transportation to shores yet undeveloped by roads. On summer holidays and weekends, a band performed on the *City of Orion* as it toured the lake. Postcards, such as this *c.* 1917 image, were common in the early 20th century and popularized Lake Orion as "Michigan's most popular resort." (Courtesy of James E. Ingram.)

On the cover: In the early 20th century, the Main Landing on Lake Orion was located where Green's Park is today. The dock with its arched proscenium was the gateway to the celebrated leisure amusements on Lake Orion. Tourists walked a few steps from the Orion train depots to this dock and through its arches onto passenger boats that took them to their island or cottage destination. This image is from around 1900. (Courtesy of James E. Ingram.)

IMAGES
of America

LAKE ORION

James E. Ingram and Lori Grove

ARCADIA
PUBLISHING

Published by Arcadia Publishing
Charleston, South Carolina

Printed in the United States of America

Library of Congress Catalog Card Number: 2006922509

For all general information contact Arcadia Publishing at:
Telephone 843-853-2070
Fax 843-853-0044
E-mail sales@arcadiapublishing.com
For customer service and orders:
Toll-Free 1-888-313-2665

Visit us on the Internet at www.arcadiapublishing.com

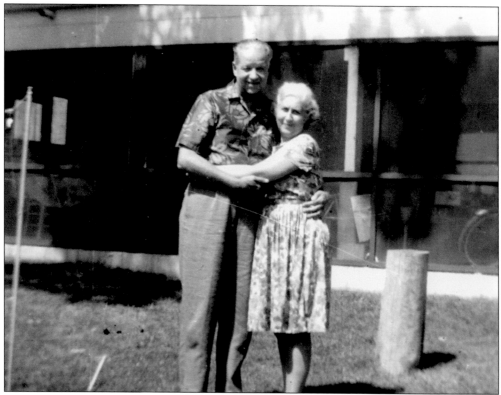

Helen Louise and James Boyd Grove, late parents of coauthor Lori Grove, bought their cottage in 1956 on Lake Orion the year Lori was born. In 1975, the cottage was remodeled into their retirement home where they lived the rest of their lives as year-round residents. They are pictured here in front of their cottage in 1968. (Courtesy of the Grove family.)

CONTENTS

ACKNOWLEDGMENTS

We thank the following for lending images used in this book: Paul A. Bailey, Charlotte Carpenter-Brown; Douglas A. Casamer; Bruce and Brad Jacobsen; Barbara Kelly-Keller; Maurine Scramlin; Mike Sweeney; Steve Hoffman; Sharyn Davis; Dale Phillips; Bud Bergman and Nancy Bergman-Johnson; Jim Bushman; Mildred Gingell; Marie Shoup; Helen Fuller-Goerlich; Jerry Gortat; Ed Roberts; David Charles Ingoglia; Glenn Rohder; Dennis and Juanita Hibbs; Gina Grove-Strubbe, Guest House, Inc.; Lake Orion Review; Northeast Oakland Historical Museum; Orion Historical Society; Lake Orion Boat Club; Orion Township Library; Archdiocese of Detroit; Cranbrook Archives; Library of Congress; Wayne State University; and the Michigan State Historic Preservation Office. We acknowledge the following for their assistance: Linda Sickles, Judi Rudisill, Kim Winther, and Gene Williams, Orion Township Library; Julia Steimel, Charter Township of Orion; Katherine Graham, Oakland County Planning and Economic Development; Robert Christensen, Ted Grevstad-Nordbrock, and Todd Walsh, State Historic Preservation Office; Lloyd Baldwin, Michigan Department of Transportation; Valarie Sobolewski, Linda Stevens, and Fr. Mike Verschaeve, St. Joseph Catholic Church; Stan Aldridge, Indianwood Golf and Country Club; Mary Ann Schlicht, Northeast Oakland Historical Museum; Luan Sherman-Offer, Sherman Publications, Inc.; James Leach, Village of Lake Orion Police Department; Jerry Richards, Lake Orion Lake Association; J. R. and Jeff Nowels, Lake Orion Lumber Company; Leslie S. Edwards, Cranbrook Archives; Bob Pawlak and Roman Godzak, Archdiocese of Detroit; Maura Johnson, Mannik and Smith; JoAnn Van Tassel, Village of Lake Orion; Kenneth Van Portfliet, village council; Sara Van Portfliet and Leslie K. Pielack, Orion Historical Society; Ted Dickens, Oxford One-Hour Photo; Fran Wilson, Oakland County Pioneer and Historical Society; Robert Remer, Jason Fleming, Bill Boik, and Craig Gray, Department of Natural Resources; Jerry Hosner, Michigan Waterski Association; Elizabeth Clemens, Walter P. Reuther Library; Mark Patrick, Detroit Public Library; Susan Benjamin, architectural historian; Kris "TigerLady" Slawinski, motojournalist; Elaine Zeiger and Karen Nordquist, the Field Museum; and staff at Guest House, Inc., and Rochester Hills Museum at Van Hoosen Farm. We thank Edward and Geraldine Smokoski, Eva and Harry Ahlborn, Charmaine Roberts-Stevenson, Jeanne Fangboner, Louise France, Becky Goodman, and William C. Saunders for their help; and John Pearson, Midwest publisher for Arcadia Publishing, for overseeing this project. Lori Grove thanks family members James B. Grove II, Judy Grove-Purewal, Gary L. Grove, Connie Grove and husband Gerrit Beneker, and Lee Weitzman (her husband); and former neighbors (not mentioned above) Helen Higgins, Janet and Terry Brewer, Carol and Tom Hudson, Alice and John Spearing, Genevieve Raines, Craig Dornton, and Philip LeBeault for their support. The Michigan Humanities Council Lakeside Cottage Project is used courtesy of the Orion Township Library; "This is the Lake that Was," courtesy of Barbara Wilson-Benetti; and *Centennial Farm: How Six Generations Farmed the Land*, courtesy of Frank Lessiter. Images are courtesy of James E. Ingram unless otherwise credited.

INTRODUCTION

The first organizers of Orion Township came from the eastern United States in the 1820s. At that time, acres of timber and lakes covered the land traveled by Chippewa and Pottawatomi nations. On Oakland Township land, purchased from the government, the eastern settlers cleared trees and erected log dwellings for their families near to where Kern and Greenshield Roads intersect today. Jesse Decker and Needham Hemingway were important forebears of this settlement and instrumental in establishing Orion as a township, a village, and a lake. In March 1835, the Decker Settlement—as it became known—was organized into a separate township called Orion. On April 5, 1835, the first township meeting was held at the home of Jesse Decker, and he was elected township supervisor.

In 1829, a dam constructed on Paint Creek for a sawmill built by Decker, Hemingway, and Philip Bigler turned the five small lakes west of it into one body of water. A large gristmill built by Hemingway in 1837–1838 below the sawmill raised the dam on Paint Creek and enlarged the newly-created body of water behind into a sizable lake that is Lake Orion today. These two mills and a tavern were about all that comprised the village of Orion when the plat was filed by Hemingway in 1838.

The waters of Paint Creek and the township's lakes powered machines that cut logs into board lumber and ground wheat into flour that was critical for the sustenance of the early settlers whose farm properties created the footprint of Orion Township. The routing of railroads in the 1870s through these properties spurred the development of flag stations as small business centers that further distributed supplies throughout the township. These entrepreneurial systems developed Orion Township into a prosperous farming community and facilitated its development as the locality of a major lakeside resort. Both its rural beauty and resort status have contributed to the suburban development that has resulted in the great lake township enjoyed today.

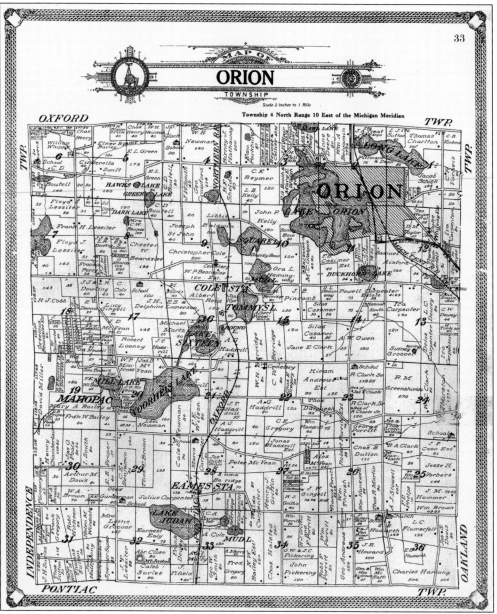

This historic map of Orion Township shows the agrarian subdivision of farms identified by family names surrounding the numerous lakes in the township. Farms continued to operate and prosper into the 1950s and many remained under family ownership, but in the 1960s, most were sold for real estate development and subdivision. Mahopac, located in the southwest quadrant of this map, was an 1840s settlement that operated Orion's only steam-powered sawmill until the 1850s on the present-day site of Mill Lake. Eames Station, located south of Mahopac along the railroad, was a flag station, where a flag was raised to stop a train for shipments and deliveries. This is from a map of Orion Township, Oakland County, Michigan, published by George F. Cram of Chicago, Illinois, in 1905.

One

ORION TOWNSHIP

As early as 1830, Jesse Decker kept a public house, or tavern, at Orion's first settlement, Decker Settlement, and became postmaster there in 1832 after which a blacksmith shop and general store opened by 1834. The farmstead of Jesse Decker, which housed the first township meeting in 1835, is depicted in this painting as it looked in the early 1900s. Located on the south side of Greenshield Road near Kern Road, it served as the home of the Bald Mountain State Recreation Area park ranger until it was demolished in the 1980s. In 2001, the site was marked with a Michigan Historical Marker. (Courtesy of the Orion Historical Society and the Friends of the Bald Mountain State Recreation Area.)

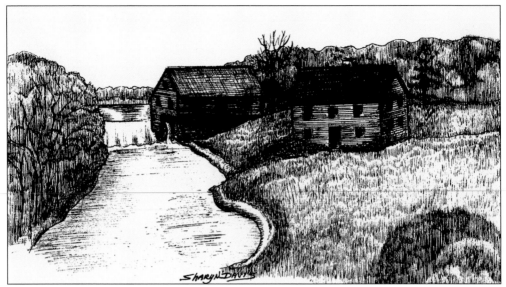

In 1829, early settlers Needham Hemingway, Jesse Decker, and Philip Bigler built this sawmill and sawyer's house on Bigler's property, located below the site of the present-day dam in Lake Orion at Lapeer Road (M-24), as shown in a re-creation of the site above. The mill was burned in 1832 by a Native American group, after which Hemingway rebuilt and became sole owner. The dam built across Paint Creek for the mill backed up five smaller lakes. (Drawing by Sharyn Davis.)

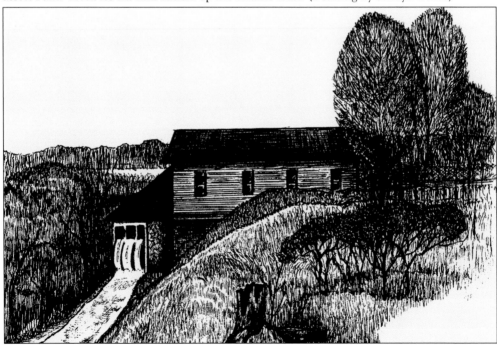

Needham Hemingway built a large gristmill below the sawmill on Paint Creek in 1837–1838, as seen in the re-creation of the site above. In order to get sufficient power, the dam across Paint Creek was raised to 12 feet, further enlarging the body of water on the west to the size of Lake Orion today. The early lake formation can be seen above the mill in the background. (Drawing by Sharyn Davis.)

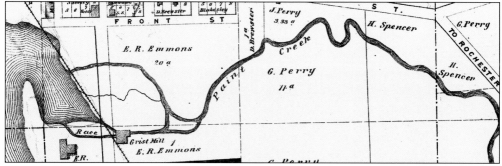

When E. R. Emmons's gristmill, shown left-center in the map above, burned in 1901, waterpower rights were acquired and a small power plant constructed at the site by John Winter and Dr. O. Lau, who were instrumental individuals in the further development of Lake Orion as a resort in the 20th century. The building housing the long-standing power plant still remains at 197 South Broadway Street, but the millrace (shown to the left of the gristmill) was filled in and redeveloped. This map is from an 1872 atlas of Oakland County, Michigan, published by F. W. Beers of New York

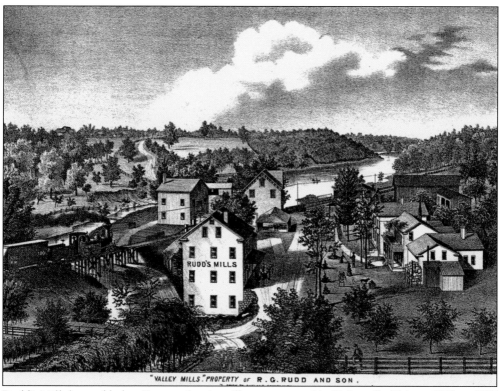

Rudd's Mill, located below Emmons's gristmill, was operated by Robert Rudd from 1865 to 1887 and was the site of one of the first sawmills in Orion Township, built there by Joseph Jackson in 1825. Powell Carpenter improved the mill site in 1835; in its heyday, almost 80,000 bushels of wheat were ground. It was last operated by W. E. Wilders in 1924 and torn down by 1927. (Courtesy of the Lake Orion Review.)

The farm of Christopher Cole was located on both sides of Joslyn Road at Newman Road and extended to the shores of Square Lake. Pictured here is a view looking south on Joslyn Road with the Cole farmhouse and barns on opposite sides of the early road. The flag station of the Pontiac, Oxford and Northern Railroad on Clarkston Road was named after the Cole family. This image was taken from *Oakland County History, 1817–1877* by S. W. Durant.

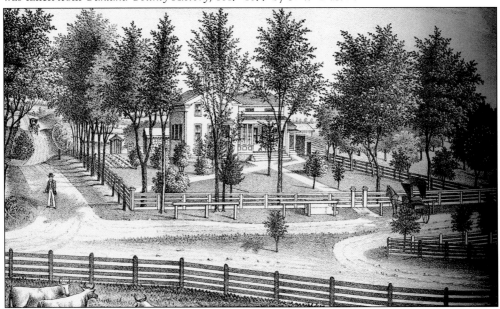

The farm of Charles K. Carpenter was located along the north side of Orion Road at Conklin Road, where the farmhouse still exists today. Carpenter, born in New York, came as a youth with his family to Orion Township in 1837. He became a member of the state legislature in 1859 and in 1872 was one of the incorporators of the Detroit and Bay City Railroad. Carpenter, with others, formed the Orion Park Association in 1872. This image was taken from *Oakland County History, 1817–1877* by S. W. Durant.

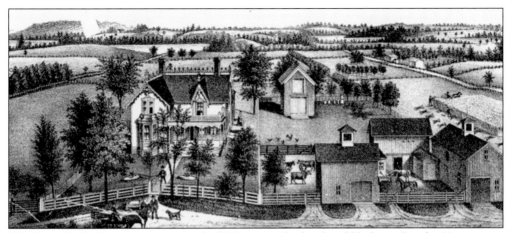

The farm of L. B. Hemingway consisted of 220 acres on both sides of Clarkston Road at Hemingway Road. The property extended west to the shore of Elkhorn Lake (formerly Mud Lake). L. B. Hemingway was born in New York in 1827 and came here with his wife, Sylvia, in 1855 to purchase his tract of land in Orion Township. Sylvia Hemingway died in the family farmhouse in 1909. This image was taken from *Oakland County History, 1817–1877* by S. W. Durant.

Orra L. Hemingway, son of L. B. and Sylvia Hemingway, continued the family farm after the death of his parents. He served as justice of the peace for Orion in the 1920s and 1930s and held an office in the village hall at a time when the justice of the peace was the local judge and conducted court business in that jurisdiction. His children Carl and Hope are pictured in the front yard of the Hemingway farmhouse around 1901. (Courtesy of Maurine Scramlin).

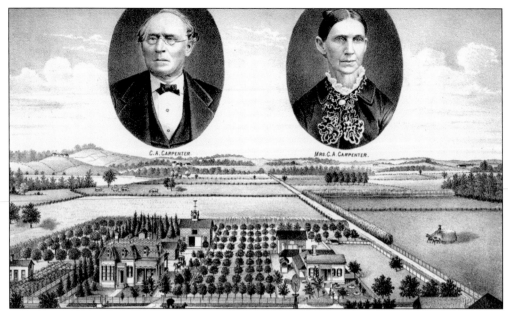

This farm, located on both sides of Joslyn Road at Silver Bell Road, was established by Charles A. Carpenter and encompassed 750 acres that extended to the shores of Judah Lake. Charles A. Carpenter came from Vermont to Orion Township with his wife, Percis Eames-Carpenter, in the 1830s, originally purchasing a 459-acre tract of land in 1845. Pictured in this drawing is the tenant house (right), the carriage house (center), the original Carpenter farmhouse (left), and Charles and Percis (top). This image was taken from *Oakland County History, 1817–1877* by S. W. Durant.

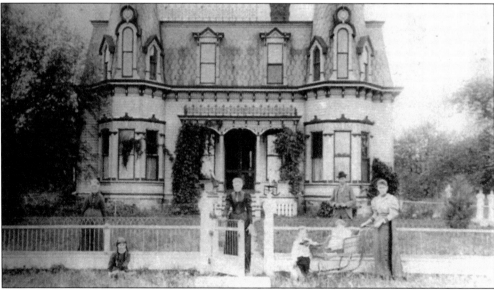

This spectacular Carpenter house was built for Julius Carpenter, son of Charles A. Carpenter and Percis Eames-Carpenter, and his wife at 3700 Joslyn Road in 1885. It had a slate mansard roof with two elaborate towers at each end. The Carpenter family is shown in the front yard. From left to right are Percis Eames-Carpenter, Minnie Carpenter, Elizabeth Rolison, Julius C. Carpenter (with hat at bay window), Oscar Carpenter, Charles A. Carpenter (in the buggy), and Maria C. Carpenter. (Courtesy of Charlotte Carpenter-Brown.)

This picture shows the elaborate interior of another Carpenter house built at 3700 Joslyn Road for Julius, the son of Charles A. Carpenter, in 1885. It remained occupied by the Carpenter family until the farm was sold for subdivision in 1954. (Courtesy of Charlotte Carpenter-Brown).

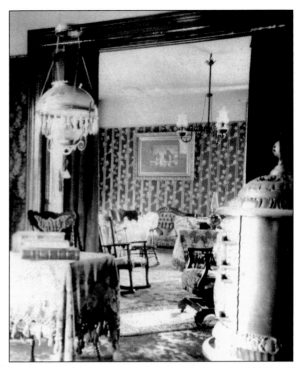

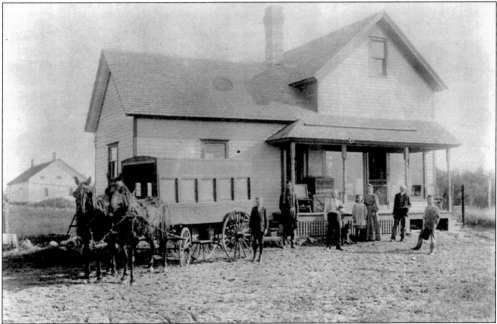

This is Eames Station on the Charles A. Carpenter farm on the Pontiac, Oxford and Northern Railroad around 1909. Named after Charles's wife, Percis Eames-Carpenter, the station had a general store that also functioned as the post office. From left to right are horses Dan and Dolly with sales wagon for traveling the roads, Clarence E. Carpenter, Charlie Gunderman, Oscar M. Carpenter (owner), Carlo (mail messenger carrier dog), E. Gladys Carpenter, Ella R. Carpenter, Julius Carpenter, and Byron D. Carpenter. (Courtesy of Charlotte Carpenter-Brown).

This house and barn, built in the 1870s on the Elijah Bailey Clark farm, were located on the east side of Lapeer Road (M-24) between Scripps and Greenshield Roads; the house was demolished in the 1990s for the Roundtree Subdivision. Born in Connecticut, Clark purchased this farmland in 1830 from the U.S. government. In 1847, Clark became a representative in the state legislature. The Clark school, a one-room schoolhouse, operated on the Clark farm for over a century. (Courtesy of Mike Sweeney.)

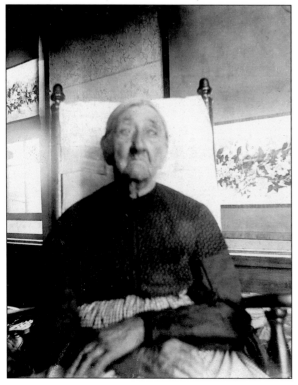

The Casamer farmhouse, built in the 1850s by Isaac Casamer, still stands west of Lapeer Road at 560 Casemer Road (the street name is locally misspelled). Isaac Casamer's wife, Prudence, worked the farm with her sons following Isaac's death in 1867 and lived in the house until her death in 1900. Pictured here at the age of 90, she was a veteran of a lifetime of farm labor in 19th-century America. (Courtesy of Douglas A. Casamer.)

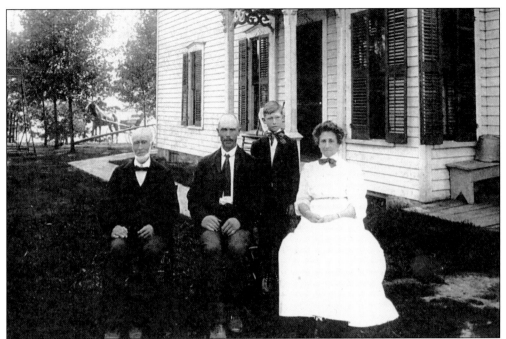

John P. Kelly, originally from New York, purchased a farm in the southwest corner of Orion Township in 1866. In 1875, Kelly additionally purchased a 200-acre farm along what is now Heights Road. Square Lake is behind the Kelly farmhouse pictured in this c. 1900 photograph; in the foreground are John P. Kelly (left) and his son Lucien's family (right). (Courtesy of Barbara Kelly-Keller.)

Known as the Lakeside Farm, the Kelly farmhouse can be seen behind the log cottage on Square Lake used by the Kellys. Pictured in front of the cottage are Lucien and his wife, Sylvia, around 1912. Lucien developed 20 acres of the Kelly property on Lake Orion in 1915 and sold lakefront lots for $75 each on Dollar Bay along what is today Shady Oaks Drive. Kelly's Landing on the west side of Dollar Bay was one of the several landings used by Lake Orion excursion boats. (Courtesy of Barbara Kelly-Keller.)

In 1930, Lucien Kelly developed the east shore of Square Lake into a park with a bathing beach, picnic grounds, ball fields, snack shop, and campground. At the height of the summer season, it is estimated that over 250 carloads of people visited Kelly's Park daily. This 1940s picture was taken when the park was managed by Homer J. Kelly and his wife, Grace. The lake frontage along Heights Road is now single-family homes. (Courtesy of Barbara Kelly-Keller).

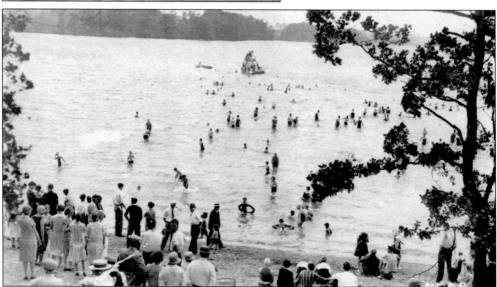

Bunny Run on Miller Road, just east of downtown Lake Orion, is another example of a farmstead turned into a subdivision and country club. The 126-acre farm, formerly owned by Jacob Schick and extending to the east end of Long Lake, was sold to the Lake Homes Realty Company of Detroit in 1924. A beach, clubhouse, and nine-hole golf course were constructed on the property. Bunny Run beach is shown on Long Lake in front of the clubhouse in 1928.

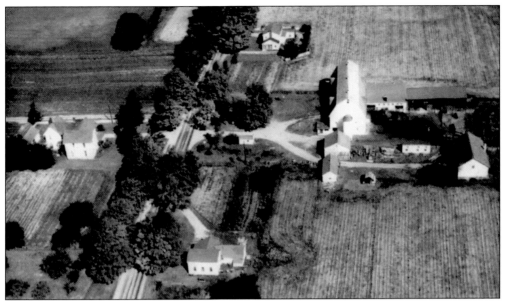

In an aerial view north along Baldwin Road is the Lessiter centennial farmstead, as seen above in the 1950s, comprising 436 acres and encompassing most of what is now Heather Lake and the Heather Lake subdivision. Cleared by English immigrant John Lessiter in the 1850s, in the foreground (right) is the original 1854 farmhouse, which became the tenant house in later years, and the large cattle barn (behind), completed by his son Frank in 1905 and one of the largest barns built in Orion Township. (Courtesy of Frank Lessiter.)

Another farmhouse (left in the top aerial photograph) was built of local white pine by John Lessiter in 1885 on Baldwin Road. The large farmhouse served as the Jersey Post Office, named after the settlers in the area from New Jersey, with John as postmaster until 1887. This table sat in one of the rooms of the farmhouse and originally had an upright rack of boxes, which held mail for the area families. The mail came out of Pontiac by stagecoach on Baldwin Road, formerly known as Steam Mill Road for the steam-powered sawmill on Mill Lake (then Mahopac) that processed a nearby stand of white pine called the "Pinery." With the advent of the railroad, the Jersey Post Office was closed. (Courtesy of Frank Lessiter.)

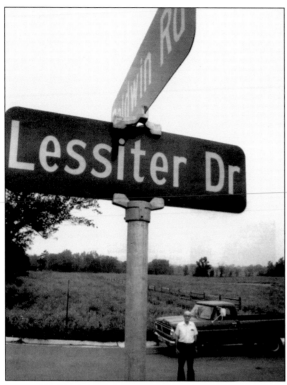

In the 1920s, the Lessiters sold farm acreage west of Baldwin Road to Oscar Weber, president of J. L. Hudson Company department store, for his farm and country estate Lakefield Farm. Milton John Lessiter (known locally as John), pictured in the background of a new subdivision street sign named after the family, sold the last of the farm acreage in 1988. Township supervisor from 1961 through 1972, he followed a family tradition of farming and civil service. (Courtesy of Frank Lessiter.)

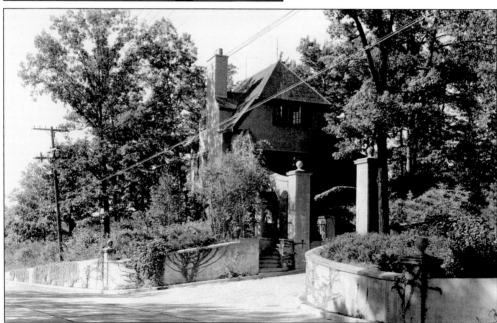

In the early 1900s, Frank W. Blair, president of the Union Guardian Bank in Detroit, bought the property on both sides of Indianwood Road from Absequami Trail to Joslyn Road for a country estate. He constructed a house with a gatehouse, pictured above, that still graces Indianwood Road today. A dam at the mouth of the stream leading from Indianwood Lake into Lake Orion, adjacent to the site of this house, doubled the size of the Indianwood Lake that is known today.

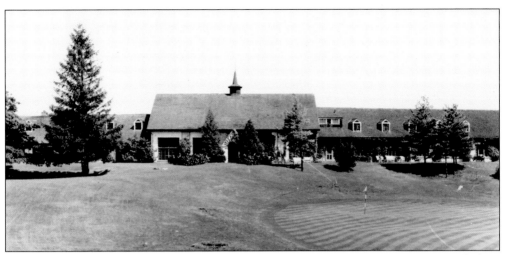

The Blair country estate included the construction of unusually ornate barns just west of where Central Drive is today, on Indianwood Road (above). In 1924, the Indianwood Land Company acquired much of the Blair property and included the Blair estate barns in the original design of the clubhouse for the Indianwood Golf and Country Club (below). In 1926, the first nine-hole golf course on the south side of Indianwood Road opened, followed by the opening of a second nine-hole course in 1927. Designed in the original style of the pastoral Scotland course by renowned English golf professional and golf course architect Wilfred Reid, the Heathland course has hosted major golf tournaments, including the Western Open in 1930 and the Michigan PGA, many times. Detroit businessman Stan Aldridge purchased the Indianwood Golf and Country Club in 1981 and restored the Scottish design to the country club and grounds that is seen today.

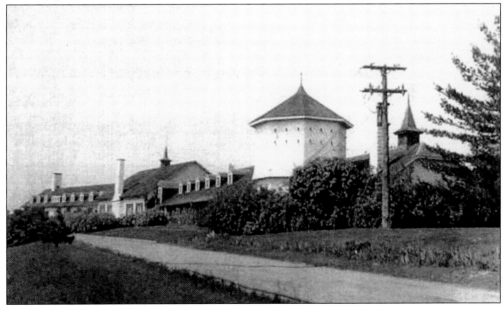

In the 1920s, on the north side of Indianwood Road, the Indianwood Shores subdivision occupied 450 acres of land with 500 waterfront lots around Indianwood Lake. The upscale subdivision was promoted in brochures such as the one on the left as "an exclusive and rigidly restricted home community with exceptional recreational advantages . . . with a select social environment." On two acres overlooking Indianwood Golf and Country Club, this home (below) at 1346 Indianwood Road was built for Earl and May Speaker in 1929 on the sloping grounds of the Indianwood Shores subdivision. Landscaped with a fishpond and surrounding garden, the private home was one of the featured historic homes in tours sponsored by the Orion Historical Society. Today residential development in similar style by Stan Aldridge continues along Indianwood Road overlooking the new course at the Indianwood Golf and Country Club. (Left, courtesy of Lori Grove; below, courtesy of the Lake Orion Review.)

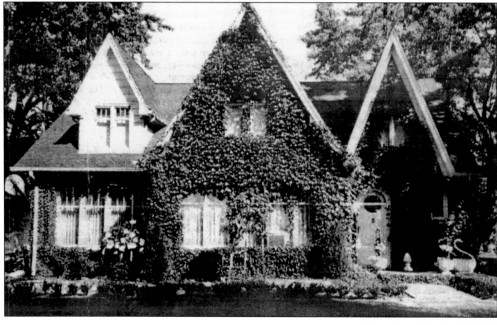

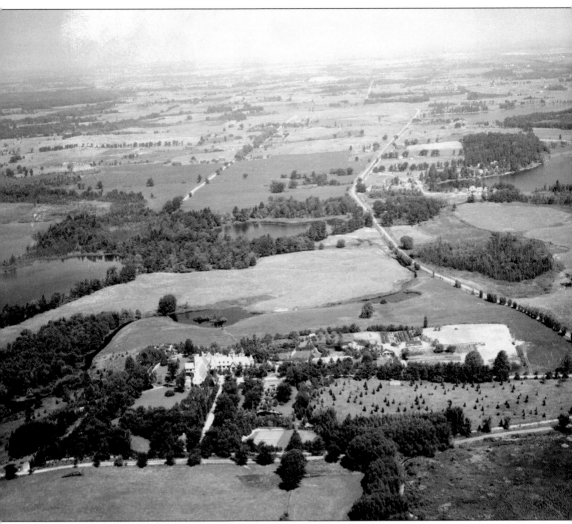

William E. Scripps began buying acreage in Orion Township in 1916 from the original settler families. By the 1920s, his farm and country estate occupied 3,600 acres that stretched from Lapeer Road (M-24) on the east to Baldwin Road on the west and from Waldon Road on the south to Clarkston Road on the north. Scripps considered farming his hobby, and his show class of Aberdeen Angus beef cattle and Guernsey dairy herds, Belgian horses, Shropshire sheep, and Duroc hogs were known nationally. Named Wildwood Farm, the estate included the Nina D. Scripps School, named after William E. Scripps's wife and built in 1924, which claimed to be the most modern rural public school in the United States. This aerial view shows the Scripps mansion with Scripps Road in the foreground, with Joslyn Road on the right winding toward the southern boundary of the vast Scripps estate. (Courtesy of the Walter P. Reuther Library, Wayne State University.)

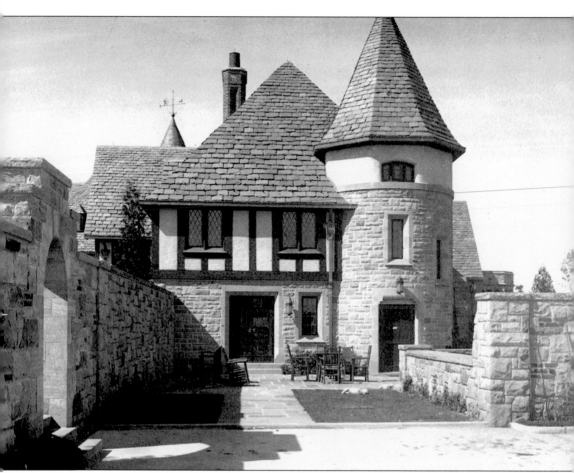

The Scripps mansion was completed in 1927 for William E. and Nina D. Scripps at Wildwood Farm, built of stone cut on site by Scottish masons. Christened Moulton Manor, its Norman and Tudor design featured the work of architect Clarence E. Day, with extensive interior and exterior metalwork by master craftsmen Oscar Bach and Samuel Yellin. The east elevation (above) housed the servants' wing, which looked out on beautifully designed gardens from its tower and adjacent windows. The pipes of an Aeolian organ extended from the basement to the third floor in its own chamber. The Scripps family used Moulton Manor as their weekend country house until the late 1930s when they moved from Detroit permanently. Newspaper magnate and only son of James Edmund Scripps who founded Detroit's *Evening News* and the nation's first commercial broadcasting station (WWJ), William E. Scripps died at Moulton Manor in 1952. In 1956, the mansion and 101 of its overall acreage was purchased by Guest House, Inc., for its Michigan treatment center for alcoholic priests. Today the center houses Catholic women religious in recovery. (Courtesy of Guest House, Inc.)

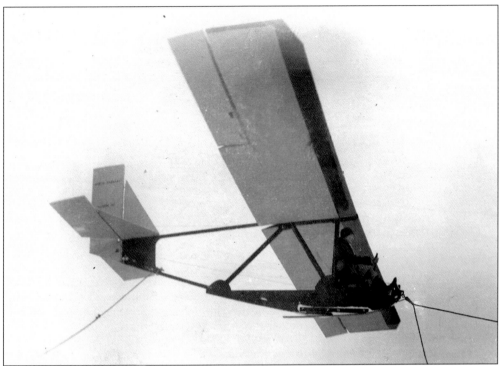

In 1928, William E. Scripps founded Gliders, Inc., the first American company dedicated to the manufacture of gliding aircraft. Amelia Earhart, the first female pilot and the first woman to fly a glider in the United States, flies a glider built by the Scripps company over Orion Township in February 1929. Earhart founded the women aviators' famous 99 Club to which some township women belonged. (Copyright Cranbrook Archives. From the Gliders, Inc. Records.)

Shown above is the row of tenant houses built for Wildwood Farm employees on the west side of Joslyn Road (now Joslyn Court). They later became part of Keatington Antique Village and are now gift shops along with many of the original Wildwood Farm barns at Olde World Canterbury Village, a tourist destination in Orion Township occupying 21 acres of the former Scripps property since 1993. Howard Keating developed some Scripps property into the Keatington subdivision along Baldwin Road in the 1960s through 1970s.

The conversion of farmhouses to places of business along Lapeer Road was partly impacted by its conversion to a state highway (M-24) in the 1930s. Shown above is the new highway winding through the township. Construction on a new segment of M-24 through Lake Orion began in 1938 and included a bridge on Lapeer Road where Lake Orion empties into Paint Creek. Prior to the construction of the M-24 bypass and bridge, one had to travel through Lake Orion's business district via Broadway and Elizabeth Streets to travel north and south through Lake Orion. (Courtesy of the Orion Historical Society, Steve Hoffman collection.)

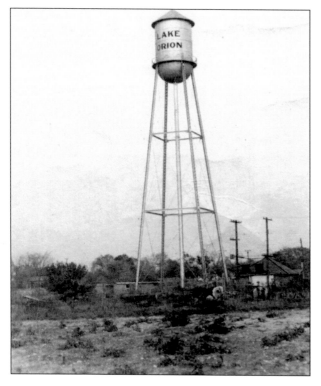

Water tanks are icons of the 19th- and 20th-century American landscape, and this water tank bearing the Lake Orion name in the 1940s speaks of a bygone era. Formerly erected at Atwater and Perry Streets in the village at what is now the location of a park, it stood as a symbol of stability through the area's remarkable transition from a prosperous farming community to a prosperous suburban community.

Two

THE VILLAGE
OF LAKE ORION

Lake Orion's first name, Canandaigua, was likely named after a thriving lakeside community in Upstate New York. James Stillson, an itinerant auctioneer, bought land on the site of the present village in 1836 and advertised it in the east as a Midwest metropolis he called Canandaigua City on Lake Canandaigua. New Canandaigua, as the town came to be called, preceded the village of Orion by two years, and they coexisted as rivals within 500 feet of each other. With the establishment of businesses and the addition of two hotels, the village settlements on Canandaigua Lake were fast becoming the economic heart of Orion Township. In 1859, the Village of Orion was chartered as a government unit and New Canandaigua dissipated. Taken from an 1872 atlas of Oakland County, Michigan, printed by F. W. Beers of New York, this map shows the village of Orion, and the island on the bottom left is Park Island today. In 1929, the name was changed to the village of Lake Orion.

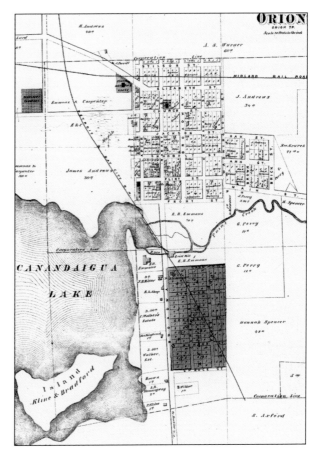

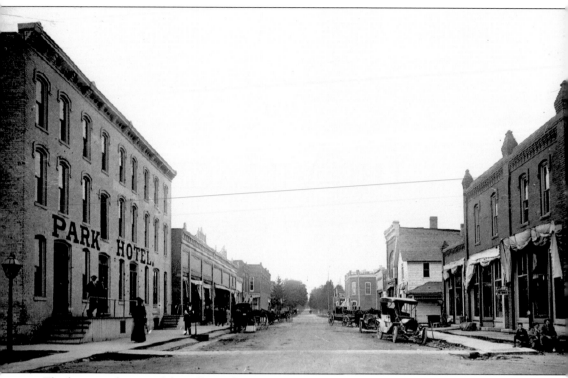

The business district of the village of Orion burned in 1874, after which masonry construction gave the downtown streetscape the face of mostly brick facades familiar today. This view, looking north on Broadway Street (formerly Market Street) from Front Street, shows Orion's largest hotel in 1911; the Park Hotel (left foreground) was built by Stephen Seeley in 1881 as the Cataract House. In 1901, it became the Hotel Taylor, and from 1908 to 1931, it had its longest-standing name of the Park Hotel before becoming the Orion Hotel in the 1930s and finally the Verwood Hotel in the 1940s. This late-Victorian building is on the Michigan State Register of Historic Sites. Across from the hotel on the northeast corner of South Broadway and Front Streets is an 1880s building historically topped by three finials, but these historic features are not evident since a 1960s renovation. George Wright, original proprietor of the Wagon Wheel Tavern, owned this building in the 1940s through 1960s.

On the east side of South Broadway Street, the clapboard building (center) is the oldest surviving building in the business district. Built of frame construction in the 1840s by Isaiah Bradford for his undertaking business, it developed into his furniture store. A century later, Dr. Hathaway had his office here. The tall Romanesque Revival storefront on the north (left) is the Berridge Building, built in 1881 and shown here occupied by Hallett's Bazaar in the early 1900s. At the end of this block is the Commercial Hotel, which burned in 1910.

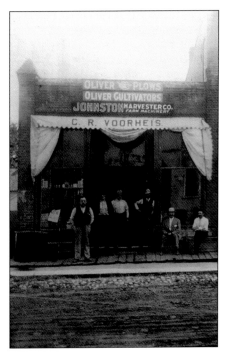

Neighboring the clapboard building on the south (right) was the L-shaped building at 47 South Broadway Street with a secondary entrance at 15 Front Street. In 1915, C. R. Voorheis operated his farm machinery store selling the latest equipment to the then farming community. Voorheis is shown third from left, and fourth from left is Byron Anderson, who later bought the store and was also village president and township clerk. In the 1920s, this storefront housed Charlie Parker's feed store. In the 1940s–1950s, the Front Street storefront became Waite's feed store.

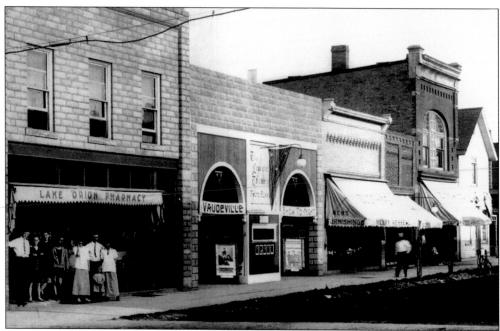

Lake Orion Pharmacy on the southeast corner of Flint and Broadway Streets neighbored Orion's first movie theater, the Lincoln Theatre, marked by the vaudeville sign seen above around 1915. Below, the Lake Orion High School Band marches past these same masonry buildings in the early 1950s. In this view, business occupants have become (from left to right) Judson Waite's IGA store, Hackers Shoe Store, and the Wagon Wheel Tavern. The tavern, when owned by George Wright in the 1920s–1930s, housed Orion's first bowling alley, accessed through a pair of metal doors in the sidewalk that opened to a stairway leading down to the two-lane basement bowling alley. The tavern moved across the street to its current location in 1981.

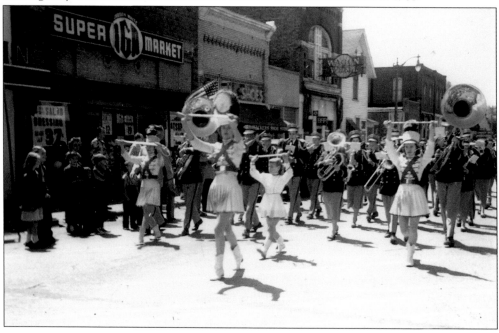

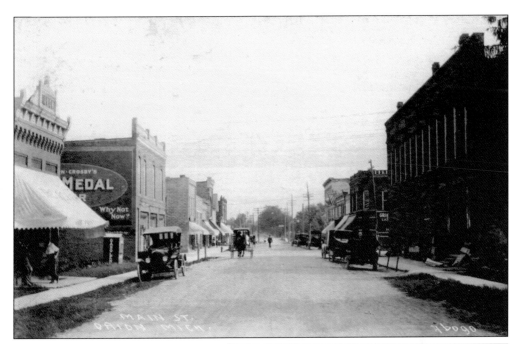

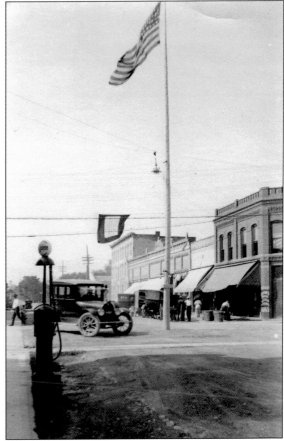

This view (above), looking south on Broadway Street from the north end of the business district, shows the four buildings that anchor the main intersection of the business district at Flint Street. On the east side (left) and marked by a Gold Medal Flour advertisement on its sidewall is Justin King's building, built in 1889. Across from it (right, foreground) is the Belles building built by brothers Andrew and John C. Belles in 1881. South of the Belles building is the crenelated roofline of the building occupied by Griggs Drug Store from 1916 into the 1960s, also built in 1881. Opposing the drugstore building is the building occupied by Ray Van Wagoner's Rexall Pharmacy from 1927 into the 1970s, built in 1912. A flagpole marks the center of this intersection (at right) in a view looking south along the west side of Broadway Street around 1915, when a gasoline pump at the edge of the sidewalk (left, foreground) had replaced the hitching posts of the 19th century. The street was paved with concrete in 1919.

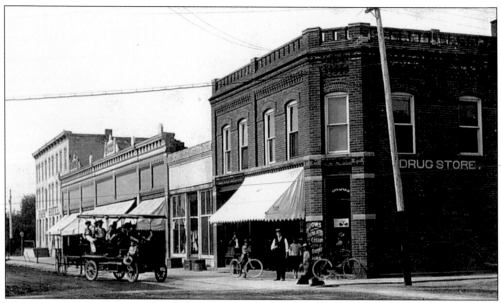

This view south of the same block around 1910 shows the corner building jointly occupied by Griggs Drug Store and the Orion State Bank, organized in 1893. The "rapid car" seen in this picture was owned by Grant Axford in 1909 and could carry 12 passengers from Orion to Pontiac, the county seat. Axford owned other, similar vehicles called Carter Cars for which local resident Roy Milner was one of the drivers.

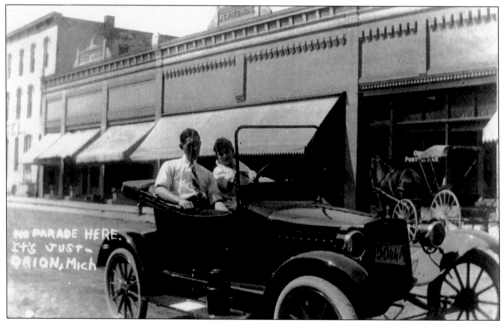

The J. C. Predmore building (center storefront) advertised "Dealer in dry goods, groceries, crockery, glassware, Yankee notions" and was built in 1903 on the site of an 1878 frame building built by Lanson Predmore that burned in 1902. In jest, the photograph is notated, "No parade here—it's just Orion, Mich." The J. C. Predmore building, last occupied by Sagebrush Cantina, was completely destroyed by fire in March 2004.

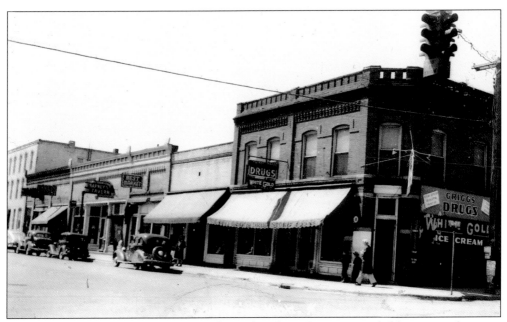

A view of the same block in the 1930s shows that A. L. Griggs expanded his corner drugstore into the entire first floor of the building. The neighboring building built in the early 1900s is L-shaped with entrances at 12 South Broadway and 21 West Flint Street. It housed the Beemer and Carlton General Store early in the second decade of the 20th century. South of it is Best Market and Barney's Tavern, then occupying the J. C. Predmore building.

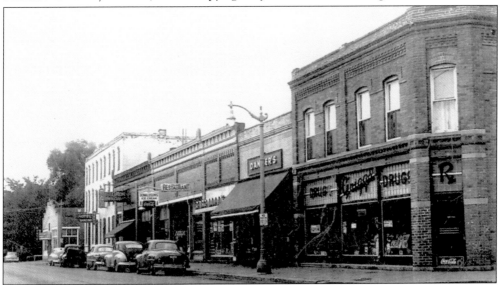

Seen here in 1951, the Griggs Drug Store has taken on modern storefront windows and is neighbored from left to right by the hotel building, John McClelland's Lake Orion Bakery (which sold to Harold Waltman in this year), the Alard's Village Restaurant, Cascaddan's Market, and Dancer's Department Store. At the very end of this strip is the State Theatre at 102 South Broadway in a building built by Charlie Howarth for his farm implement factory and sales in 1913. In 1915, it became his Ford automobile dealership in Lake Orion. (Courtesy of Mike Sweeney.)

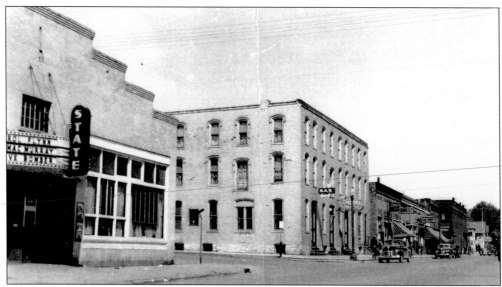

The former Park Hotel, the tallest building in the business district at three stories, is shown above (center) as the Varadee Hotel for a brief time in the 1940s. It later operated as the Verwood Hotel, and today it is the Verwood Apartments. The State Theatre marquee (foreground) features the Warner Brothers epic *Dive Bomber*, starring Errol Flynn and Fred MacMurray. The theater building became the Lake Orion Youth Center in the 1960s and now houses the Wagon Wheel Tavern.

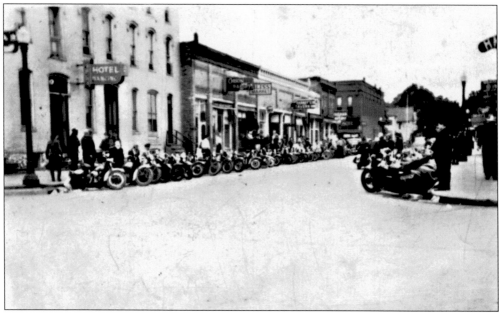

In May 1942, Lake Orion was occupied by a "motorcycle convention" just six years before the formal organization of the notorious outlaw group Hell's Angels Motorcycle Club. Lake Orion's taverns and dance halls were frequented by motorcycle clubs in the 1940s and 1950s as rallies like these were commonly held at venues such as lakes and small towns. The hotel bar and Barney's Tavern, shown in the background, were probable destinations for this biker group. (Courtesy of Mike Sweeney.)

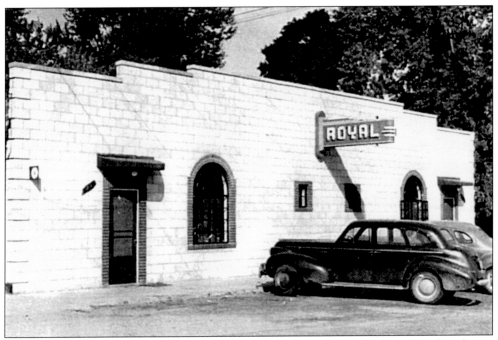

The Royal Recreation (above), located one block east of Broadway Street at Front and Anderson Streets, was a popular bowling alley in Lake Orion that featured six lanes, a bar, and a dining room. Pete Hammelef and Burt Skelly built and opened it in 1939, and Hammelef soon became sole owner and remained in business here into the 1960s. Behind the bar (below) on January 3, 1943, are owner Burt Skelly and bartender Minnie. At the bar are Ted Cole (with hat) and Ben Steiner (white shirt). At the table (from foreground to left) are, Frenchie Dupler, Ben Greenless, Harold Weimeister, and Red Morin. The others are unidentified. (Courtesy of the late Joyce Steiner-Fangboner.)

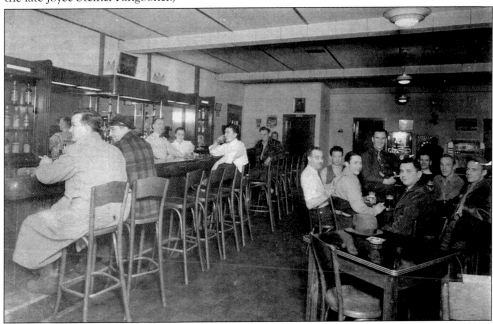

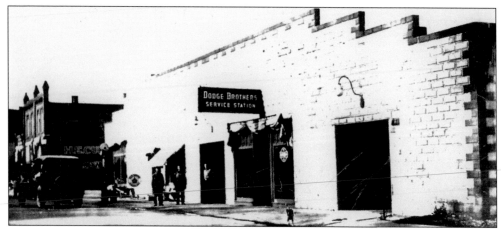

Earl Speaker built this building (foreground) in the early 1920s on the site of his father's 19th-century blacksmith shop. Located on the east side of South Broadway Street, he operated his hardware store, Speaker and Son Hardware, in the South Broadway–Front Street corner with a car repair garage in the section closer to Paint Creek. He sold the garage to C. D. Shafer, who operated a Hupmobile dealership, a Dodge-Plymouth dealership, and finally an Oldsmobile dealership at this location.

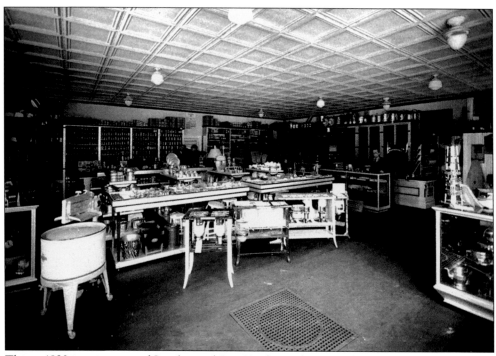

This c. 1930 interior view of Speaker and Son Hardware shows employee Harold Ingram, father of coauthor James E. Ingram, in the far corner behind the glass showcase on the right. Harold later owned this hardware store from the early 1940s to 1969.

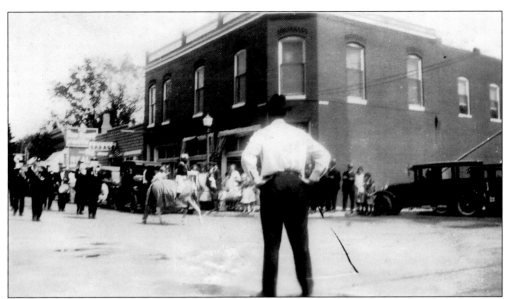

A celebration of Orion Day (above) was described as "dry and dandy" for a parade heading south on Broadway Street at Flint Street in 1926. The King building on the corner was the site of the Simms' house and barn in the 1870s, followed by the village well. This commercial Italianate building with a "clipped" corner housed the Maccabees organization on the second floor in 1903, Guy Lyon's grocery store from 1910 into the 1920s, followed by the Kroger store. Below, from left to right are Pearl and Fred Wieland, and Lillie and Guy Lyon in front of the grocery store. (Below, courtesy of Jim Bushman.)

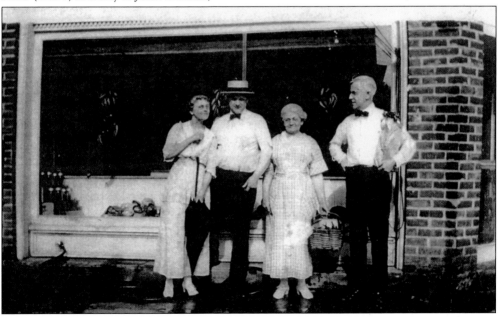

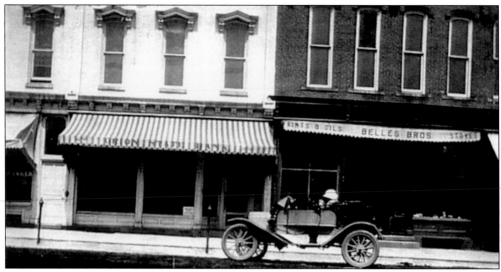

On the northwest corner of West Flint Street and North Broadway Street, brothers Andrew and John C. Belles (great-grandfather of coauthor James E. Ingram) operated their general store on the first floor and Belles Hall on the second, which accommodated over 200 people for parties, dances, and roller-skating. In this c. 1910 view, the Orion State Bank operated out of the neighboring building (left), built by W. E. French at 22–24 West Flint Street in 1881.

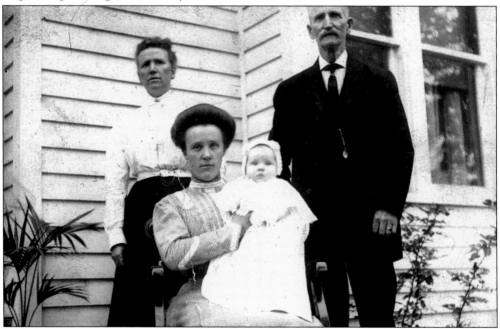

The Belles family has a long-standing history in Orion Township and is the maternal lineage of coauthor James E. Ingram. Pictured above are three generations of the Belles family; seated is James E. Ingram's grandmother Ethel Winter-Belles holding his mother, Esther, and behind them are his great-grandparents Mary Porrit-Belles and John C. Belles outside their home at 343 North Broadway Street in Lake Orion around 1909. The house is still used as a residence in the village today. In 1915, Ethel Winter-Belles and J. L. Belles built the arts and crafts–style brick bungalow at 609 East Flint Street at Orion Road, where Esther was raised.

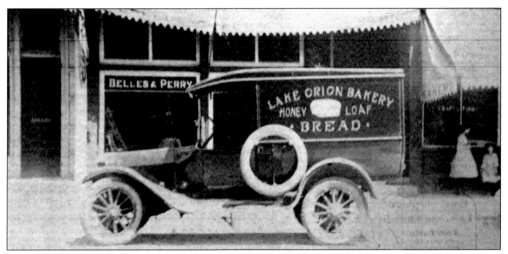

In the 1920s, J. L. Belles (son of building owner John C. Belles and grandfather of coauthor James E. Ingram) and George Perry established the Belles and Perry Hardware store in the west half of the Belles building. The delivery truck shown in front belonged to the Lake Orion Bakery, run by the Bergman family, located in the east section of the Belles building (not shown). (Courtesy of the Lake Orion Review.)

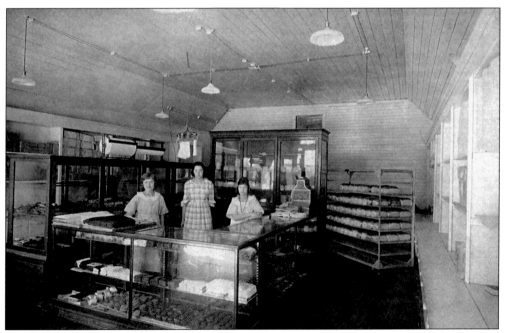

The Lake Orion Bakery occupied the east half of the Belles building and was established in 1913 by William Bergman and his son William Jr. Operated by family members, sisters Martha (left) and Ella Bergman (right) pose with an unidentified coworker in the showroom around 1919. The Bergman family operated the bakery at this location into the 1930s. (Courtesy of Bud Bergman and Nancy Bergman-Johnson.)

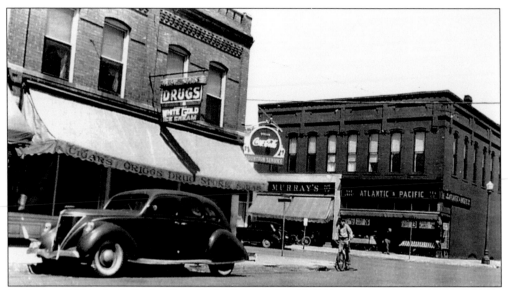

By the late 1930s, the Belles building (right) housed the A&P (Atlantic and Pacific) Food Market on the northwest corner of the business district's main intersection and Murray's department store in the west half, with the Masonic temple on the second floor. Originally built as Griggs Drug Store, Patterson's Pharmacy (left) occupied the drugstore building in the 1970s, followed by Art Accents, and today it is occupied by Ed's Gifts.

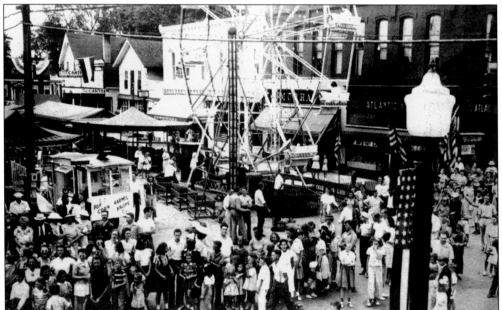

The annual Fourth of July carnival has occupied the Broadway and Flint Streets intersection in front of these buildings since the 1940s. Buildings along the north side of West Flint Street in the 1940s, shown from west to east (left to right), had the following occupants in the downtown business district at that time: the Orion Township Public Library, Dr. Watson's medical office, Barney's Restaurant, Allen's Furniture Store and Orion State Bank in the French building, and Murray's department store and the A&P Food Market in the Belles building. (Courtesy of the Lake Orion Review.)

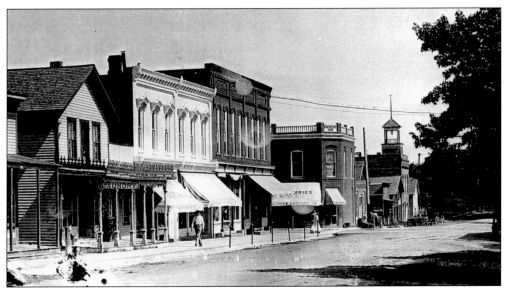

A view east along the north side of West Flint Street in the early 1900s includes the prominent masonry facades of the French building, Belles building, and King building. Village hall, built in 1900, is farthest east with the rooftop tower that housed an iron triangle used to summon the fire department. An electrified siren replaced the iron triangle in 1920. Village hall was listed on the Michigan State Register of Historic Sites in 1981 and now houses village offices, council chambers, and the Village of Lake Orion Police Department.

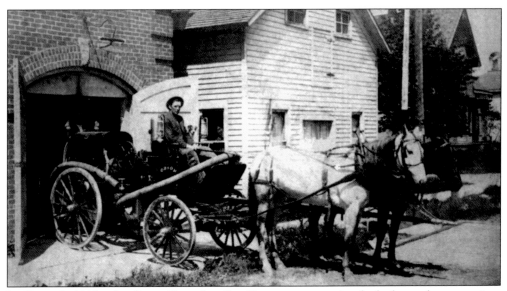

In the early 1900s, the Orion Township Fire Department consisted of a horse-drawn carriage that carried water and hoses to a fire site, as shown here outside village hall. Large, arched double doors provided access for the horse-drawn firefighting equipment. The white frame building to the east (right) was a beanery for processing farmers' beans. In the background (far right) is the rooftop of the Allen Funeral Home, which served the township and village until the 1970s and is now the Sparks-Griffin Funeral Home.

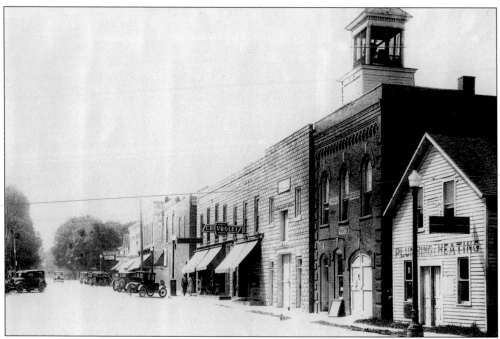

A view west along the north side of West Flint Street features village hall with its rooftop tower. The concrete block building neighboring village hall on the west (left) was used to house horses that pulled the fire engine and stored hay and feed on the second floor; it was razed for the 1980 village hall expansion. In 1926, the Orion Township Public Library was founded on the second floor of village hall and operated there until 1940. (Courtesy of the Lake Orion Review.)

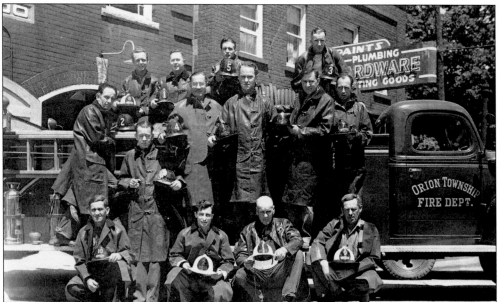

Shown above are the volunteer members of the Orion Township Fire Department in the 1940s, in front of village hall where they are based. From left to right in the first row are firefighters Ed Smith, Ray Sims, and Glen Shafer, with George Schick left in the second row, and Art Cotcher second from the left in the third row. (Courtesy of Mike Sweeney.)

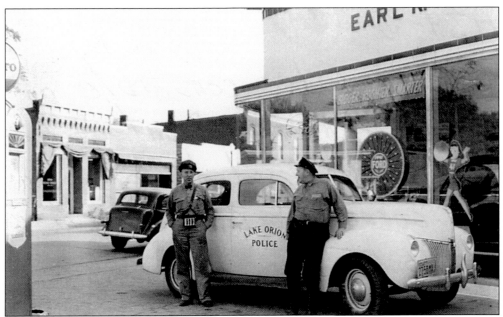

The local village police car is parked in front of Earl Milliman's Ford dealership on the southwest corner of North Broadway and Shadbolt Streets around 1940. Local constable George Cole (right) is shown with Floyd Lamphere, who operated the gas station at this intersection. The building on the left across North Broadway is the Orion Review building at 30 North Broadway, built in 1884 for the medical practice of Dr. Davis. Since 1903, the Lake Orion Review newspaper (formerly the Orion Review) has occupied this building. Located behind the Orion Review building was Abe Deere's large blacksmith shop (below) that operated from 1900 into the 1920s when blacksmithing was a viable occupation in the village. (Above, courtesy of Mike Sweeney.)

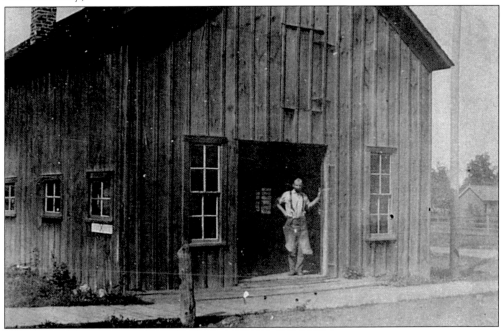

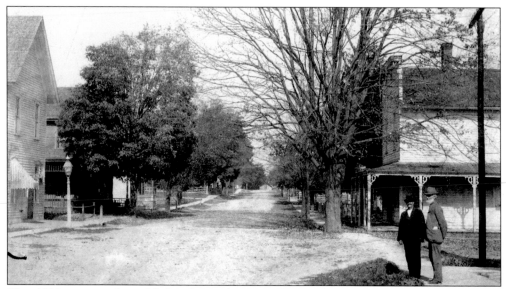

This 1884 view north on Market Street (now North Broadway Street) is at the intersection of Shadbolt Street. The building on the right in the foreground was the first home of the *Orion Review*. The building was moved one lot east and became the duplex that it is today at 25–27 East Shadbolt Street. The two men are unidentified. The building directly across from them housed the offices of Dr. J. W. Fox and, in 1884, became the Grange hall. The Latter Day Saints purchased the building in 1919 and used it as their church until 1945. The building stands today at 10–14 Shadbolt Street. (Courtesy of the Lake Orion Review.)

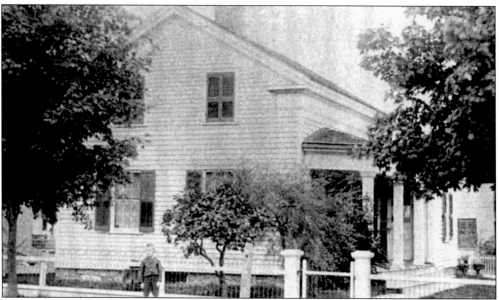

This house at 148 North Broadway Street was built by John Hall in 1861. It was purchased in 1877 by John A. Neal, who established the local newspaper, the *Orion Review*, in 1881. The Neal family lived here until 1909 and continued to publish the newspaper into the 1950s. The name was later changed to the *Lake Orion Review*, which was purchased by Sherman Publications in the 1960s. The house still sits on the southeast corner of North Broadway and Jackson Streets. (Courtesy of the Lake Orion Review.)

Joshua C. Predmore built this fine house at 244 North Broadway Street. A successful farmer, he organized the Orion State Bank with Ira Carpenter in 1896. Predmore served in many public offices and was Orion township clerk when he died in 1912. A Civil War veteran, he was on guard duty at the White House the night Pres. Abraham Lincoln was assassinated. In 1979, the house was listed on the Michigan State Register of Historic Sites. (Courtesy of the Michigan State Historic Preservation Office.)

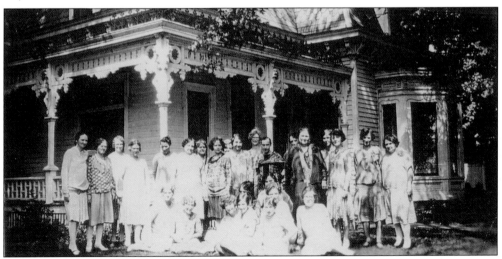

This house was built in 1884 by James M. Letts, who owned E. S. Letts and Son Lumber Company at 215 South Broadway Street and had access to the skills and materials used for its ornate craftsmanship. The Lettses' lumber business was bought by R. W. Nowels in 1948 and operated as the Lake Orion Lumber Company, which is run today by grandsons J. R. and Jeff Nowels in the same complex of buildings from the Lettses' era. A women's society was photographed in front of this house at 209 East Flint Street in the 1920s.

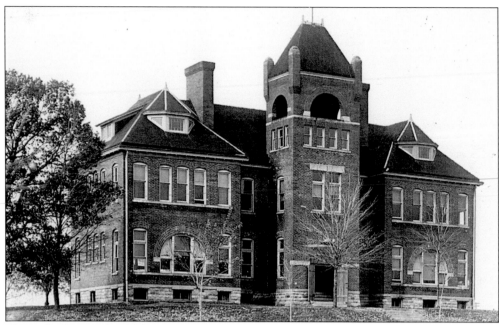

This Lake Orion school (above), built in 1893 on the southwest corner of Elizabeth and Lapeer Streets, sat high on the hill, and the four-story bell tower dominated the village skyline at that time. It was said to be one of the finest schools in Michigan for grades 1–12. It was demolished in the 1930s by a Works Progress Administration project as part of the program designed by the Franklin D. Roosevelt administration to provide jobs. The school building on the corner of Elizabeth and Lapeer Streets known today as the Ehman Center (below) was built in 1927 to replace the 1893 school and operated into the 1990s. The Boys and Girls Club is now housed in the Ehman Center.

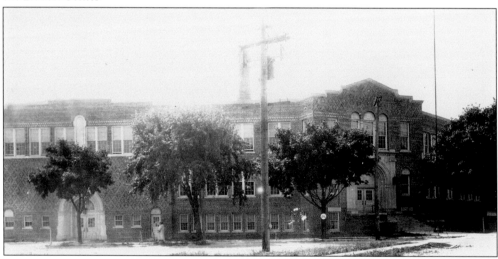

One- and two-room schoolhouses
served the community from the
mid-1830s into the early 1950s for
grades one through eight. They were
built in multiplicity and scattered
around the township to ensure that
children would not have to walk
more than two miles to school.
Mildred Gingell stands outside the
Wilson School around 1916 (right),
formerly located on the north side
of Waldon Road just west of Joslyn
Road. Lake Orion's first school was
built in 1844 on the northeast corner
of Church and Anderson Streets and
is today a private residence (below).
(Right, courtesy of Mildred Gingell.)

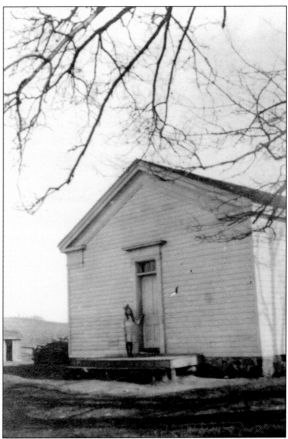

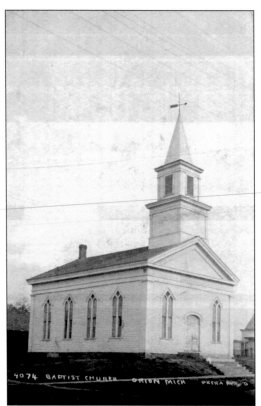

This Greek Revival structure was built in 1854 by several Protestant denominations that could not afford a church of their own—thus they named it Union Church. Initially used by the Congregationalists and the Methodists, the Baptists used the church from 1912 until 1972. In the 1970s, it was used as the village hall. Now under restoration, it is one of the oldest churches on its original site in Oakland County and is listed on the Michigan State Register of Historic Sites.

This building on the southeast corner of Shadbolt and Beebe Streets was built in 1925 as the first Catholic church in the village. As can be seen in this contemporary picture, it is still being used as a church. From the early 1940s through the late 1960s, this building was also used as Lake Orion's first youth center, the Drag-On-Inn, which was one of the first youth centers in Michigan.

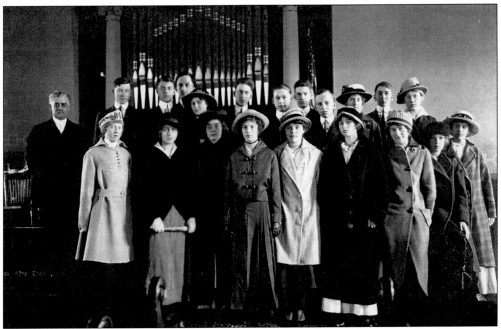

This is an Orion High School graduating class from the early 1920s in front of the pipe organ in the Methodist church at Flint and Slater Streets. At that time, it was common for some graduation ceremonies to take place in this church. Built in 1872, the same year as the Michigan Central Railroad tracks, the frame structure was moved in 1901 to its present location due to its proximity to the noise and hazards of the railroad tracks. The Italianate church is listed on the Michigan State Register of Historic Sites.

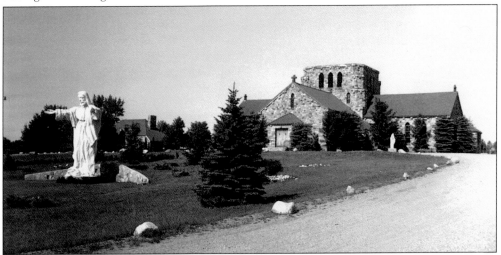

St. Joseph Catholic Church was erected in 1940 of fieldstones collected by area farmers. From the west side of M-24, just north of Indianwood Road, its cruciform configuration faces north, south, east, and west. Commonly called "St. Joe's" and "the church of four seasons," its Normandy-style stone interior features botanical-inspired stained-glass windows representative of the four seasons. It underwent extensive renovation and expansion in the 1990s, and the molded fiberglass statue of Christ erected in front in 1958 was dismantled in 1963. (Courtesy of the Archives, Archdiocese of Detroit.)

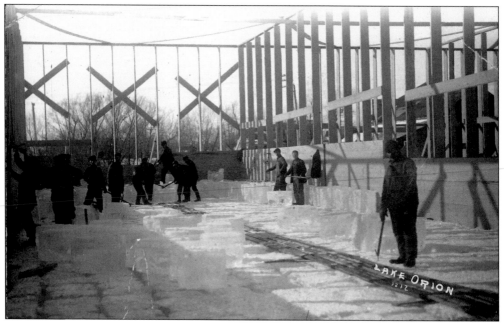

In 1906, Pittman and Dean erected icehouses on Long Lake across from present-day St. Joe's. Men stacked blocks of ice inside the icehouse, after which the walls and roof were completed. A 1924 article in the *Orion Review* cited, "More ice is harvested in the vicinity of Lake Orion than in any other section of the county . . . Pittman & Dean Co. . . . have filled 14 houses with a total of 35,000 tons . . . $16,000 would be a low estimate of the local ice pay roll."

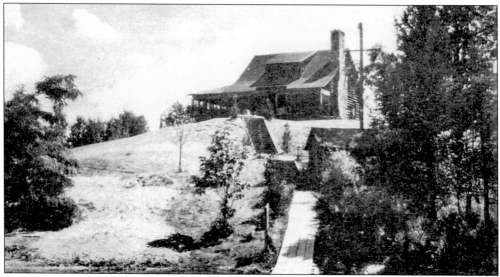

In 1923, Charles A. Dean gave use of his cabin on Long Lake and the 200 acres surrounding it to the Franklin Settlement, Detroit's oldest settlement house designed to assist and educate the children of the poor. Known initially as Dean's Camp, Camp Franklin offered a nine-week summer camp session and remained active into the 1980s. In the 1990s, the property was developed into the Shores of Long Lake subdivision.

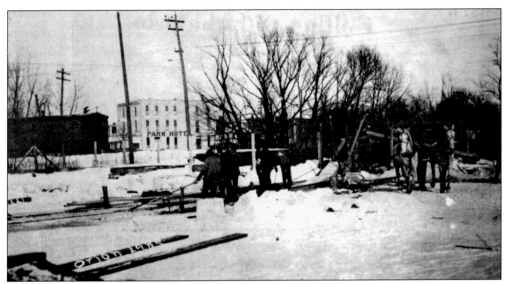

In 1908, Hacker and Mackrodt Company of Detroit built its icehouses in the center of the village of Orion. Huge slabs of ice were taken from the lake, and a horse-drawn sled was used to bring them to a conveyor belt that took them into the icehouse. There, they were cut into blocks and stacked. Throughout the year, they were transported by rail and sold in Detroit. Here a crew of men harvest ice at the shoreline of Lake Orion with the Park Hotel in the background. (Courtesy of Mike Sweeney.)

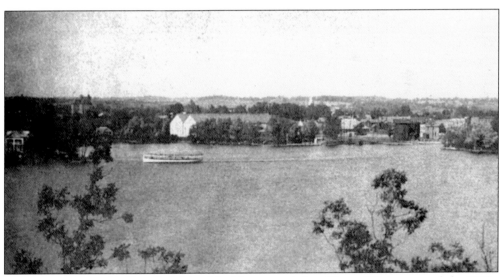

This view is from a bluff on Park Island looking toward the village of Orion around the 1920s. The two long white buildings (center) are the Hacker and Mackrodt Company's icehouses. On the far left is Simmons Point with the *City of Orion* excursion boat passing in its direction. Above them, the 1893 Lake Orion school dominates the northeast skyline, and the steeple of the Methodist church is barely seen to the right above the treetops, behind the icehouses.

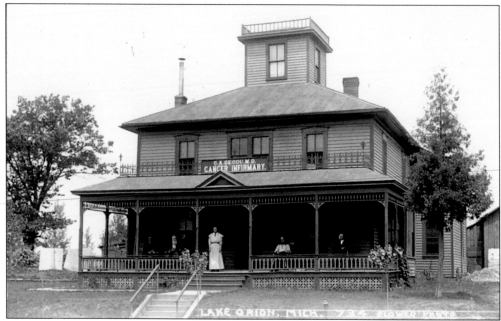

The DeCou Cancer Infirmary formerly stood at a site just east of what is now M-24 near Flint Street and was erected by brothers Dr. Jacob DeCou and Dr. Charles DeCou in 1889. Jacob had developed a method that seemed highly effective in treating cancer and in 1888 moved from Detroit to escape the "malarial influences of the large city." The infirmary was in a quiet and rural location accessible by railroad, and the *Medical History of Michigan* cites that patients from all parts of the United States came for treatment there.

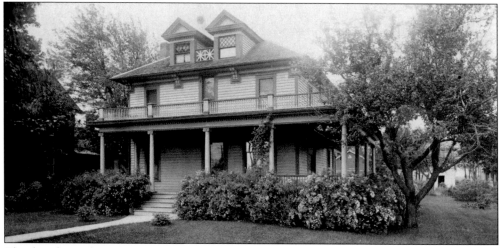

This handsome house at 236 South Broadway Street was bought by Henry and Mary Griffin in 1912 and has been family property for four generations. It was occupied by their daughter Elizabeth with her husband, G. Grover Shimmons, whose daughter Marian with her husband Bill Bailey joined them in 1945. Their son Paul A. Bailey with his wife Dawn converted the house to a duplex, and in 1978 the law offices of Paul A. Bailey were established there. Henry Griffin died in an ice-cutting accident on Long Lake in 1921, and G. Grover Shimmons served as a mayor of Lake Orion and township treasurer and lived in this house until his death in 1972. (Courtesy of Paul A. Bailey.)

This fourth-generation family business started in 1920 when Charles V. Jacobsen and son Harold purchased an 1890s "run-down greenhouse." Operating from this site at 545 South Broadway Street (right), Harold's sons engaged in the business following World War II, and today great-grandson Brad Jacobsen is Lake Orion manager of Jacobsen's Flowers and Garden Town. The greenhouses extend approximately 10 acres east from Lapeer Road. The original store (left foreground) is shown in a 1950s aerial view next to a white farmhouse (right foreground) where Charles Jacobsen and wife Carrie lived. Below, shown around 1960, the Mahopac Inn (foreground) was a tavern south of the farmhouse that was purchased by the township in 1939 to serve as Orion's township hall. It later became the senior center and a sheriff substation. It is now a warehouse for Jacobsen's, which bought the township property in 1996, and Garden Town consumes the site of the farmhouse that was moved to Pontiac Drive in 1959. (Courtesy of Bruce and Brad Jacobsen.)

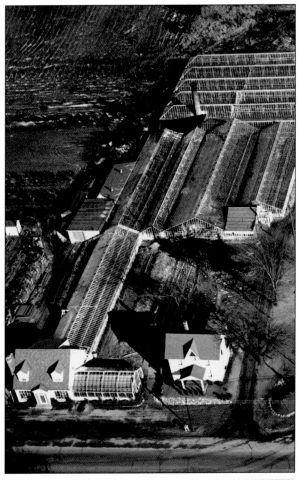

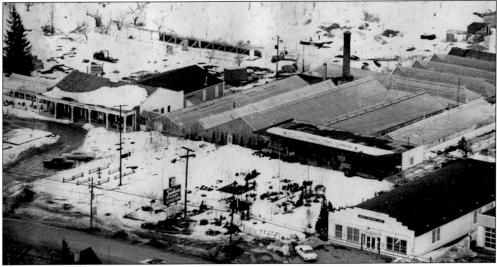

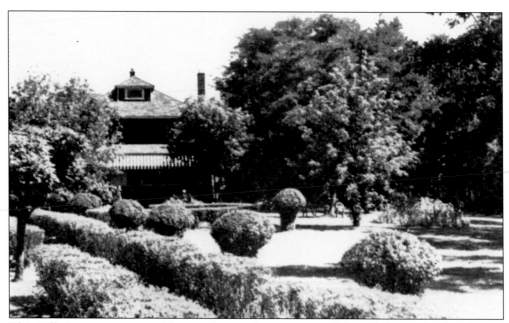

This Villa Inn restaurant and bar on the northeast corner of East Clarkston Road and M-24 sits behind the site of the former Bella Villa, Lake Orion's first drive-in restaurant, operated by the Sorebelli family in the mid-1940s. By 1950, they obtained the first liquor license in Orion Township and established the Villa Inn in the large farmhouse behind the drive-in. There, they entertained Brace Beemer, the first radio voice of the Lone Ranger, and Jimmy Hoffa, past president of the Teamsters Union. This is now the site of Christi's Bar and Grill.

This building, now the Kruse and Muer Restaurant at 801 South Lapeer Road, has a long and rich history. It was built as a farmhouse in 1860 and in the 1930s was converted to a restaurant known as the Buckhorn Inn. Mr. and Mrs. Otto J. Benaway purchased this restaurant and renamed it Cedarhurst in 1935. In the late 1930s, Gus Kalohn purchased it and by the 1950s had a liquor license. He operated the bar-restaurant with his two sons, Pete and Paul, into the 1980s under the name Gus' Steakhouse. Pete later opened Pete's Roadhaus on M-24, which has since become the Hamlin Pub.

Three

THE MAIN LANDING AND PARK ISLAND

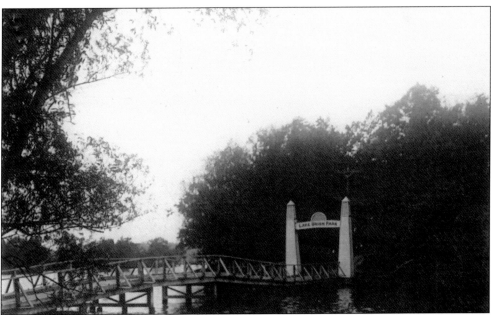

The Detroit and Bay City Railroad in 1872 set the stage for Lake Orion as a major summer resort. In 1874, E. R. Emmons and several prominent citizens formed the Orion Park Association. They developed a park on the shore of the lake in the village (now Green's Park) and operated a steam-powered launch for lake excursions. They purchased Island Park (now Park Island) and constructed a bridge to the island where they built a 100-foot-long reception hall topped with an 80-foot-high observation tower. In a natural amphitheater that seated several hundred people, a rostrum was erected for public speakers. The Spiritualists were among those who camped on Island Park each year for religious assemblies before it became a popular amusement park in the 20th century. (Courtesy of Mike Sweeney.)

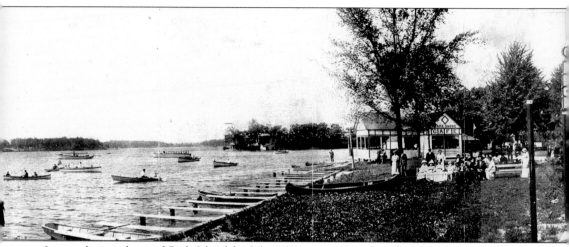

It was the purchase of Park Island by John Winter in 1911 that established the amusement center on the island and developed the Main Landing next to two tracks of railroad, as seen in this panoramic view, as the entrance to the summer resort. A fleet of passenger launches and the Lake Shore Café are shown on the left, and the Lakeside Hotel, operated by the Green family, was located just north of the Main Landing. The Michigan Central Railroad depot is on the right in the background. A footpath leads from the Detroit Urban Railway platform in the foreground to the entrance arches. John Winter, who owned Lake Orion Summer Homes

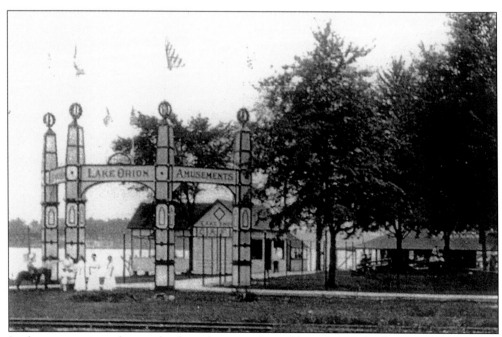

In the summertime, thousands of people per week would arrive to Lake Orion and depart their trains, cross under these arches, board a launch, and be taken to their hotel or cottage.

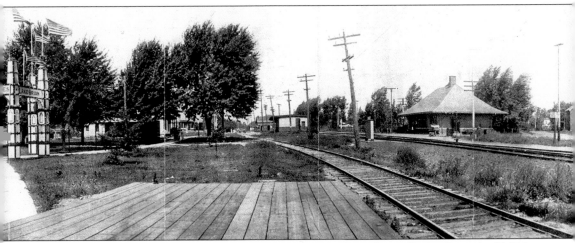

Company and kept a sales office here, sold this property to the Village of Lake Orion for $9,000 in the 1930s, and it became Green's Park. The Lakeside Hotel was operated by the Green family, for whom the park is now named, from 1900 into the 1930s. It was a small hotel with 10 to 12 rooms and a dining room, and prior to 1900, it operated under a different name. The building became a doctor's office in the 1950s and was torn down for an expansion of Green's Park in the 1980s. (Courtesy of the Orion Historical Society.)

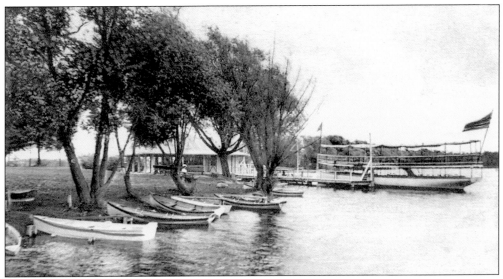

Visitors could also linger at the Main Landing at lakeside Rest Pavillion (pictured above) or rent a canoe, rowboat, or launch "at a moderate rental by the day, hour, or week." (Courtesy of the Orion Historical Society, Steve Hoffman collection.)

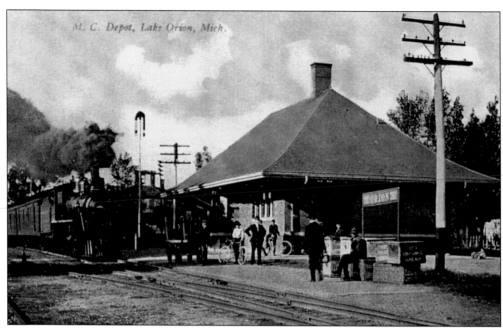

The Michigan Central Railroad depot for steam-powered railcars is pictured above in 1901. It was on the southeast corner of M-24 and Flint Street and torn down in the 1960s for a building erected for A&P Food Market (now occupied by AutoZone). The Detroit United Railway passenger depot was located on the southwest corner of M-24 and Flint Street, adjacent to the Main Landing (the current location of Orion Marine). John Winter and Dr. O. Lau were instrumental in having the Detroit United Railway line run from Rochester to Lake Orion in 1900, and the depot seen in the picture below was built shortly thereafter. The Detroit United Railway ran throughout southeastern Michigan, and from Lake Orion, it ran north to Flint and into the "thumb" region, or Saginaws.

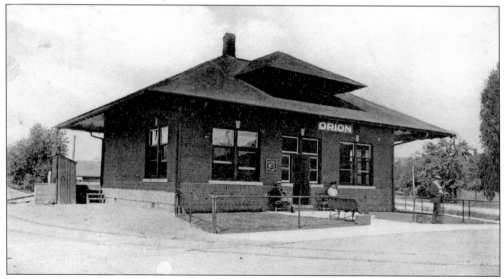

This foldout brochure was circulated via the U.S. mail in 1914 to advertise Lake Orion's amenities as "unsurpassed in all Michigan" and easily reached via rail and electric lines for healthful amusements, summer comfort, splendid views, desirable hotels, summer cottages for sale and rent, and its fleet of passenger boats. Families were assured that "the safety and comfort of ladies and children are made the special concern of the management." Lake Orion was also stocked annually with bass, pickerel, and pike, and fishing contests were held seasonally as well as amateur photography competitions of scenic Lake Orion views. (Courtesy of Lori Grove.)

This postcard speaks to the fact that Orion was a place to be in the early 1900s. With the lure of its natural setting for picnicking and leisure amusements, it was likely very conducive for one to be "detained in Orion." In many brochures and newspaper travel articles, it was advertised as the "Venice of the Middle West," "Paris of Detroit," and "Lake Orion, the One Best Resort."

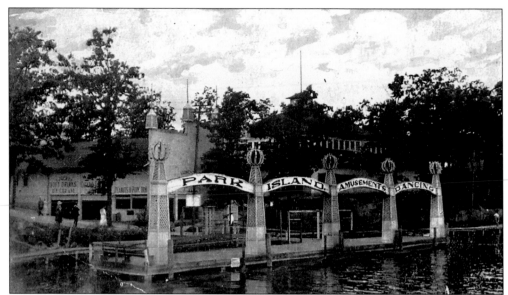

Park Island was the destination of launch and excursion boats where passengers were unloaded to spend the day at the amusement park. At the Park Island landing (above), passengers disembarked beneath its arches for "amusements and dancing." On the left behind the arches is the building that housed the penny arcade and souvenir booths. The building above the landing on the right housed the carousel.

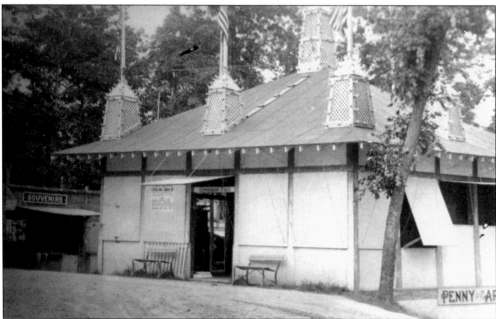

A penny arcade allowed one to play a video-type game for a penny, except in 1915, one had to crank it by hand. Many buildings were adorned with decorative elements characteristic to Park Island, such as these truncated pillars on the rooftop that are strung with hundreds of lights for illumination at night. The Orion Light and Power Company, established in 1901 by John Winter and Dr. O. Lau, initially furnished electricity for the resort and village. In 1912, it was purchased by the Detroit Edison Company under which name it remained in operation until the 1950s.

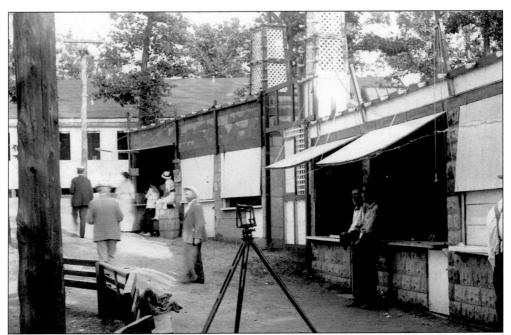

Visitors on Park Island could mill between buildings and booths and find activities of their choice. In the style of an open-air market, this aisle of booths was used for various games and souvenir shops in the 1920s. There were also refreshment booths, lunch stands, and a dining room on Park Island.

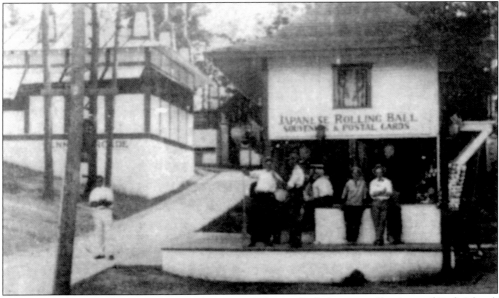

Japanese Rolling Ball was a very popular game. When asked about recollections of Park Island, most people recall playing this game and the type of prizes they won. Marie Shoup, village resident, described the game as rolling billiard-sized balls into certain holes for a cumulative score with which one would win prizes that varied from Kewpie dolls to fine pieces of china. Women residing in Lake Orion could acquire many pieces of china this way, and sometimes a complete set!

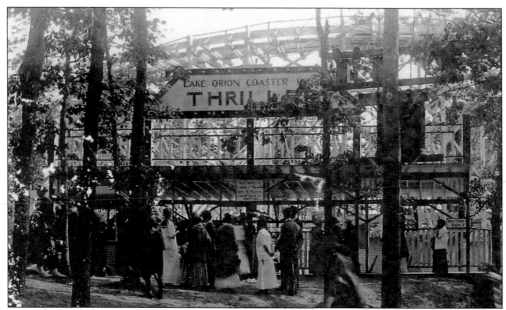

The Thriller roller coaster was another of the main attractions on Park Island. It was located at the southwest corner of the island and towered above the trees. Former resident Barbara Wilson-Benetti recalls, "When the cars hit the long drops, the metallic rattle of the acceleration carried across the water quite plainly, like a keg of nails being poured down a brick chute; and along with it came the high-pitched screams of the girls. These came out as one sound, a long 'R-r-r-r' as the car fell and simultaneously a high 'E-e-e-e' trailing out behind like a ribbon." A footbridge (below) ran from the back side of Park Island near the Thriller to the current location of Algene Street on the mainland. Algene Street is named after Al and Geneva Dacey, who lived on this street in the 1920s through the 1950s.

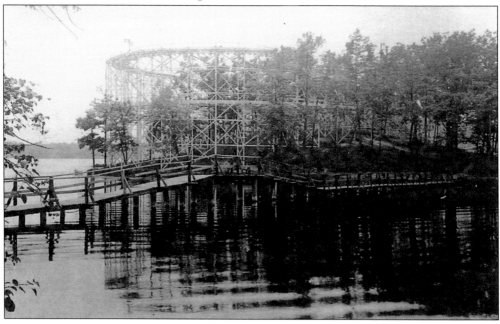

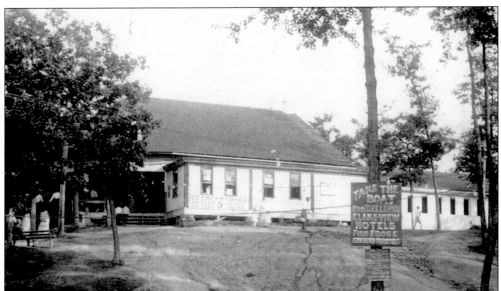

A dance pavilion was one of Park Island's most enduring attractions (above, around 1910, and right, in the 1920s) and attracted major bands such as Butler's Band from Detroit and Logan's Lansing Orchestra. Over the years, three dance pavilions were built on the island. After the first was destroyed by fire, it was replaced by a second, more elaborate pavilion with 5,000 square feet of floor space. On the Fourth of July weekend in 1936, the second dance pavilion burned to the ground in one afternoon. It was said that it burned so fast the band did not get their instruments out. The dance pavilion was again rebuilt, and it continued to attract major bands into the 1940s.

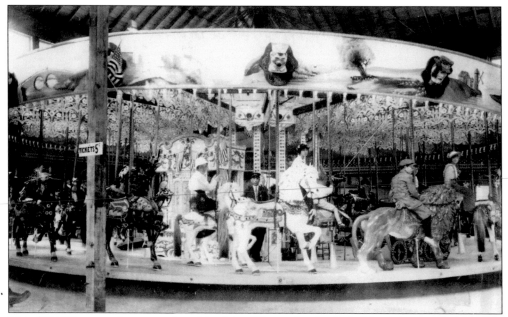

This $12,000 carousel was purchased by John Winter for the Park Island Amusement Park in 1915. Some of the beautifully crafted horses had real horsehair for tails and moved up and down as the carousel rotated. Toward the center of the carousel were carriages in which people could also ride and benches where the less adventurous could sit. Vincent Borelli, standing in the center, ran the carousel. He was Italian and allowed only Italian opera music to be played for the carousel's operation.

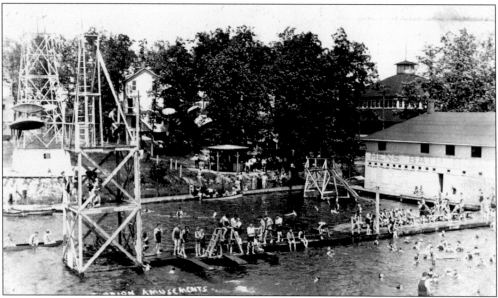

The swimming beach located on the north side of Park Island had both a men's and ladies' bathhouse in addition to a two-story observatory. It also had a large L-shaped dock with several diving boards and platforms. The highest of these at the very end of the dock was 42 feet, and lifeguards would put on diving exhibitions late in the afternoons. The carousel was housed in the building seen in the background (right).

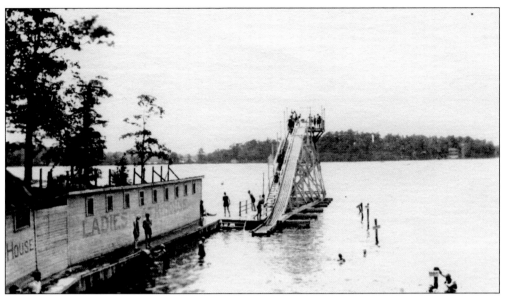

The Park Island beach boasted the largest waterslide in Michigan located next to the ladies' bathhouse (above). At the beach there, three bathing beauties pose on a raft (below) around 1920. Bathing suits such as these could be rented from the bathhouse.

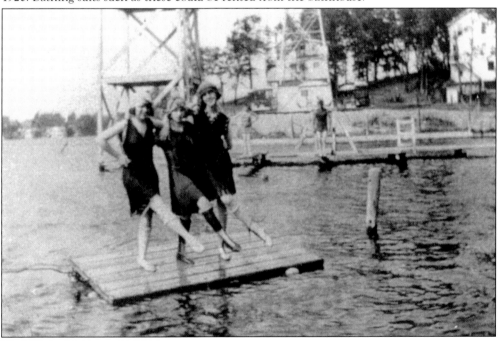

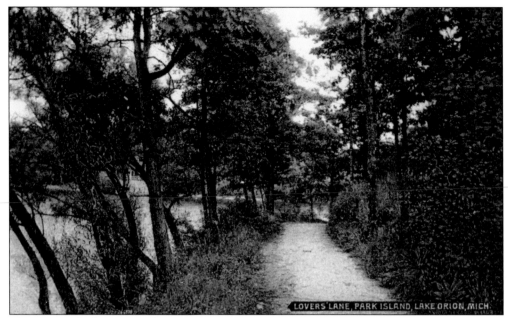

This postcard advertises a designated Lovers' Lane for couples to slip away from the noise and crowds in order to take in a romantic stroll on the island. (Courtesy of the Orion Historical Society, Steve Hoffman collection.)

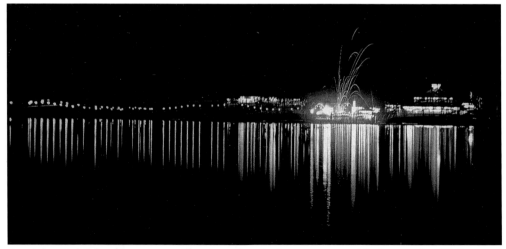

At night, Park Island became an illuminated park. It was strung with thousands of lights, and it was said that "the myriad lights transform the islands and shores into a veritable fairyland." Firework displays exploding against the dark sky were a frequent nighttime event over the lake, as shown above. The origin of Lake Orion's name is purportedly taken from the night sky. In 1911, J. A. Treat reported that his father, while an Orion postmaster, suggested the name of Orion "because it was short, handy to write, and 'altogether lovely,' it being the finest constellation in the heavens." Prior to this name change, Orion had also been called Dogway due to a quantity of mongrels in the business district.

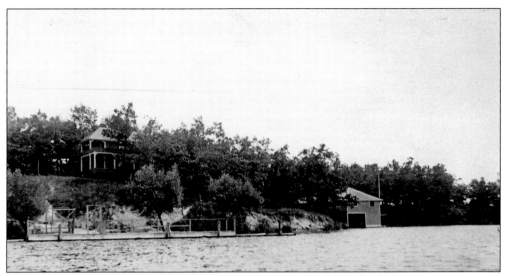

There were at least three summer cottages on Park Island when the island became an amusement park, and they were used to house employees of the park. This cottage on Park Island is high on a bluff with a sizable boathouse and dock at the water level. The two-story cottage displays a wraparound porch on both levels to enhance the vista of the lake. The wraparound porch was a common architectural feature of the early Lake Orion cottages.

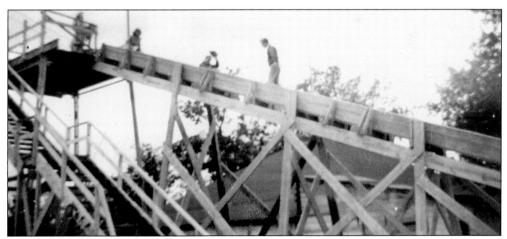

In the 1930s, due primarily to the Depression, Park Island as an amusement park descended into steep decline. The rides and most of the buildings were being torn down. A toboggan slide (right) was made of lumber from the old Thriller roller coaster. It was erected on the north side of the island in the late 1930s. The toboggan run shot toboggans down onto the ice where they would glide almost to Green's Park in the village.

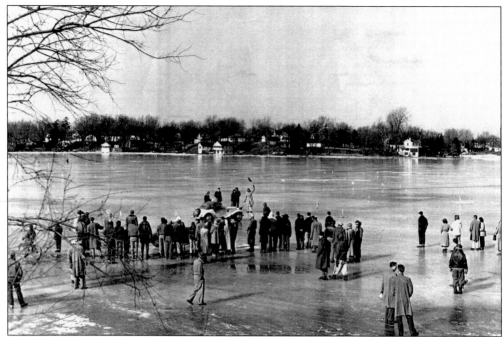

Other winter activities on Park Island in the 1940s were sport car races and skating races on the ice. The view of this sport car race (above) is looking north from the island toward the village on an idyllic winter day when the ice was smooth as glass. Livingston "Bud" Schaar, a late village resident, recalled ice-skating around Lake Orion as "big time" when the whole lake was an open skating rink. By 1955, his brother Stid Schaar's bar on Park Island was about the only active establishment and was destroyed by fire that summer. In 1964, Bill Davis purchased Park Island (below) and replaced the wooden bridge with a concrete bridge (right). He then developed the island with lakefront homes.

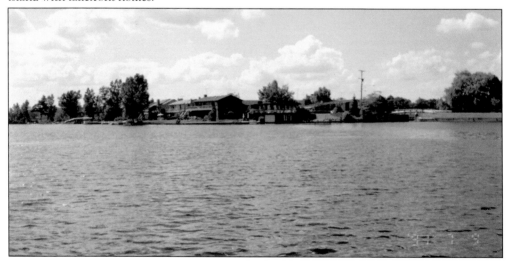

Four

BELLEVUE ISLAND

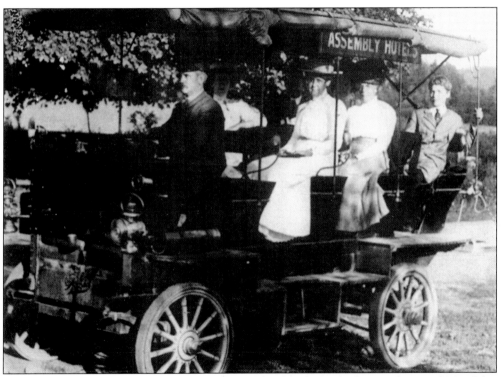

Bellevue Island was formerly known as Spencer Island and was the home of Mr. and Mrs. John Meyers, who kept a peach orchard. From two houses on the island, they rented rooms to summer vacationers. In 1898, the Assembly Resort Association was formed by John Winter and J. T. Haller, who purchased the island as a permanent location for the religious summer schools and assemblies of the chautauqua. They built a wooden bridge, a large auditorium, two hotels, and cottages on the island. In 1914, Bellevue Island became the "Chautauqua of Lower Michigan" and was also called Assembly Island through the 1920s. If one was a guest at either of the two assembly hotels on the island, one could be chauffeured around the lake and into the village of Orion in this modern, motorized shuttle.

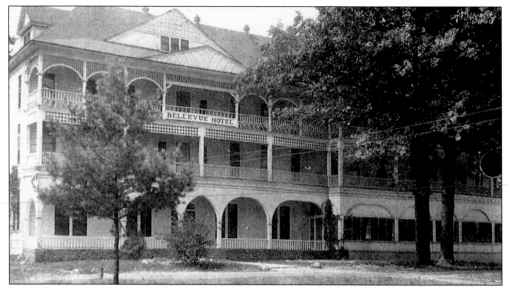

The first section of the Bellevue Hotel was built in 1899 on the east shore of Bellevue Island, and it doubled in size by 1903. In 1900, rooms rented for $5 per day, which was a considerable sum in those days. Longtime resident Bill O'Brien remembers that the dining room was screened on two sides with views of the lake, and meals were served on linen tablecloths with the best crystal and china while wandering musicians serenaded the diners.

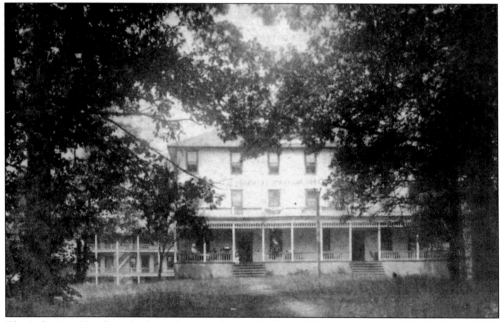

The Lakeview Hotel was built on the west shore of Bellevue Island just north of the bridge in 1900. It was considered more affordable than the Bellevue Hotel with rooms renting for $2.50 per night. The hotel restaurants on the island were the major eating establishments on Lake Orion at that time. A 1914 postcard says, "Spent the day at Lake Orion and ate dinner on the island."

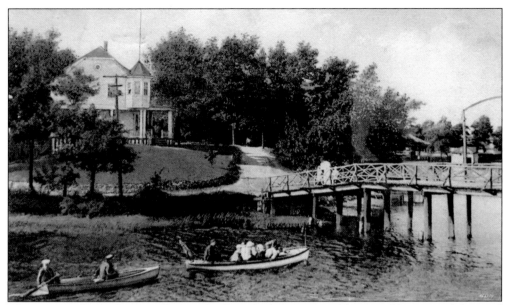

This wooden footbridge to Bellevue Island was built in 1897 and later used by automobiles until replaced by the concrete Bellevue Bridge in 1928. Pictured at the foot of the bridge on a hill is an elaborate cottage called Briar Hill, owned by Dr. Brem, a professor of astronomy at the University of Michigan from about the 1920s through the 1940s. The cottage burned in 1949.

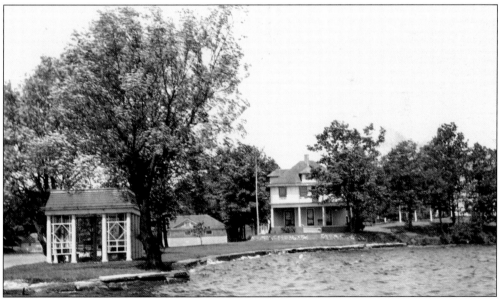

Point Comfort is where John Winter built his summer home in 1901 on a peninsula on the east shore of Bellevue Island. A gazebo on the point stood as a landmark on the lake for most of the 20th century. Servants' quarters and a boathouse were located between the gazebo and the main house. Located at 99 Crescent Drive, Point Comfort was sold after John Winter's death in 1939 and converted to a year-round home.

In the early 1900s, an auditorium was built in the middle of Bellevue Island to seat 2,250 people on the shore of a lagoon, as shown in this rare print image (above). To access the auditorium, a channel was cut from the main body of the lake that enabled attendees to arrive by boat and moor along the shore of the lagoon. The auditorium was the base of activities for the chautauqua and a speaking platform for evangelists that included Billy Sunday and Homer Rodeheaver and even the politician William Jennings Bryan, who presented his famous "cross of gold" speech there. Concerts, church services, and theater performances occurred at the auditorium all summer long. Below is a brochure announcing programs for the 25th season of the Lake Orion Bible Conference on Bellevue Island in 1930. (Below, courtesy of Lori Grove.)

SUNDAY PROGRAMS

SUNDAY, JULY 27

10:30—Sermon
 Dr. Cassius E. Wakefield
2:30—Sermon
 Dr. H. H. Savage
7:00—Galilee Service
8:00—Sermon
 Rev. Harris H. Gregg
 "Twice Born Men"

SUNDAY, AUGUST 3

10:30—Sermon
 Bishop W. F. Oldham
2:30—Sermon
 Captain Reginald Wallis
7:00—Galilee Service
8:00—Sermon
 Captain Reginald Wallis

HOW TO GET THERE

DRIVE TO LAKE ORION over the best of roads, and across the bridge directly to free parking space near the Auditorium, on Bellevue Island, 35 miles from Detroit.

ELECTRIC CARS from Detroit, Flint, Saginaw, Bay City, etc.

MICHIGAN CENTRAL RAILROAD—Bay City Division passes through the village of Lake Orion.

MAKE RESERVATIONS of rooms at Epworth Cottage, or (women and girls only) at the Grace Cottages, Lake Orion, Michigan.

LAKE ORION
BIBLE CONFERENCE

Lake Orion, Michigan
on Bellevue Island

❧❧

Twenty-fifth Season

❧❧

July 27th
August 3rd
1930

A view of the lagoon shows the undeveloped island with a faint footpath leading through the trees along the shore in the upper right. These footpaths are what became the vehicular roads around Lake Orion, which is why many of them are so narrow by today's standards. The water tower that supplied the Bellevue and Lakeview Hotels is seen on the upper left of the postcard.

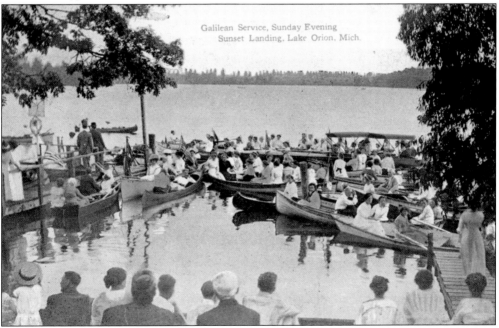

This postcard shows a chautauqua gathering for church service aboard boats at Sunset Landing. This service occurred at sunset on Sunday evenings throughout the summer at various landing docks around the lake as a means to accommodate all the visitors staying in all parts of the lake. The minister administered service from the docks backed by a choir, and at Sunset Landing a pump organ was wheeled down from the auditorium for the service.

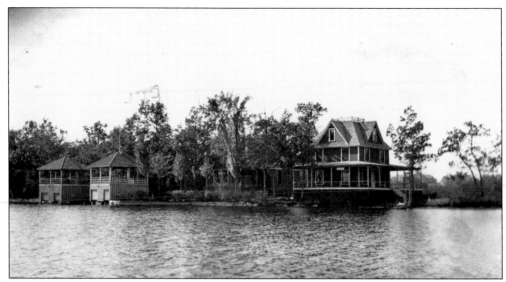

Longpointe, a peninsula of land extending northeast from Bellevue Island, was formerly known as the Arm. The large summer cottage on its point (right) was a landmark on the lake for most of the 20th century. It was owned by Dr. O. Lau in the late 1800s and by Guy Wilson, father of locally known artist and writer Barbara Wilson-Benetti, until the early 1930s. It was destroyed by fire in the 1970s and today is replaced by a year-round home.

Ye Old Homestead is the name of this cottage at 532 Longpointe. It was built in 1887 in keeping with most of the 1880s cottages originally built along Longpointe, and has been in the Wisner family since 1913. Family members continue to summer there now. Ardis Wisner, whose father purchased the cottage when she was 10, recalled fondly the Saturday night "wienie roast," which drew summer residents from all over Bellevue Island.

The former Martin cottage is located on Longpointe, on Bellevue Island. In the early 1900s, it was owned by Mrs. Read, who rented rooms with board (meals) to summer guests. Many cottage and home owners around the lake did this to augment their incomes. The footpath in front of the cottage is now a one-lane road. Many of the roads around the lake initially were footpaths, accounting for their narrowness today. A large porch was a common feature on most cottages, as users spent most of their time outdoors "in a wondrous setting of deep green verdure" as one travel writer wrote about Lake Orion in 1945. This former cottage is still well preserved as a year-round home by the Dendel family at 552 Longpointe.

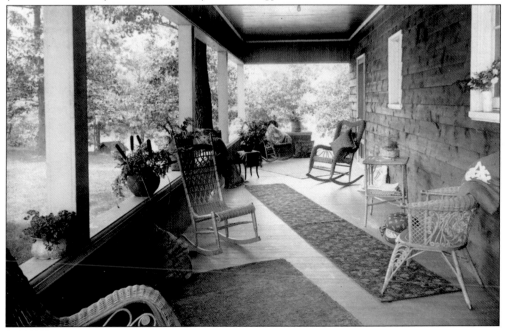

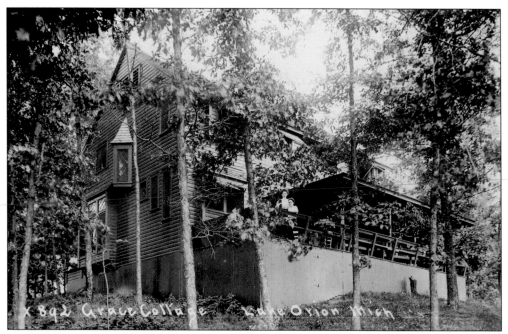

Grace Cottage, established as the YWCA cottage for Bellevue Island (although actually located on the mainland), is described by this early-20th-century guest in a postcard (above) sent home: "This is the Y.W.C.A. Cottage on the island and so nice for the working women from the city when they take their vacation for the rates are cheap enough for them to have a good outing and not cost them so much. It is such a pretty place . . . so glad about cottage . . . my isn't it fine?" This lakeside view shows how large the cottage was. Built in 1903, it had an arts and crafts–style porch with a wooded view (left) in the back. It accommodated approximately 20 women at a stay. The original cottage is still at 230 Bellevue Road but has been remodeled over the years.

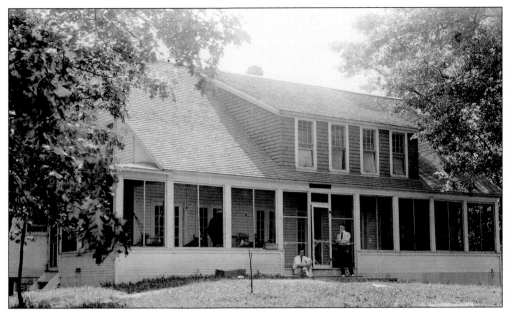

Another group cottage was the Epworth League Cottage. It was built by the Methodist Church to house its youth groups attending the chautauquas in the center of Bellevue Island, high on a bluff with a commanding view of the lake. Located at 75 Bellevue Road, it has since been converted into apartments.

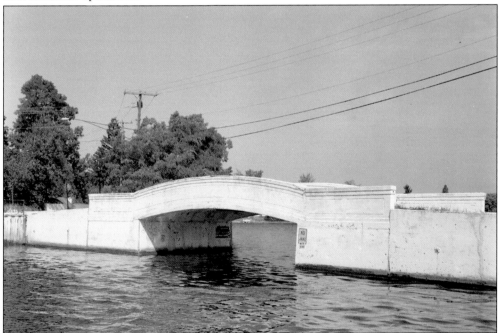

Stokes and Whittingham were the engineers who designed and built the first concrete Bellevue Bridge for vehicular traffic in 1928. Providing an underpass for boat traffic between the east and west bodies of the lake, boats frequently tooted horns as they passed beneath. Deemed unsafe in the 1990s, it was recorded as a cultural resource by the Historic American Engineering Record and replaced by the present-day Bellevue Bridge in 2003. (Courtesy of the Library of Congress.)

Bill and Mary O'Brien bought this summer cottage at 15 Highland Avenue (above) from his mother in 1946, after it had been winterized for year-round living in 1934 by enclosing two of three porches and insulating the second floor. Called the Oakland, his father purchased the cottage in 1914, and they brought their servants with them from Detroit, who stayed above the boathouse for the summer. Members of the infamous Purple Gang summered nearby at a cottage at 24 Highland Avenue in the 1930s (below). Bill reported that, although a branch of the Detroit Mafia, they were always good neighbors. Sold from the estate of Mary O'Brien in 2004, the Oakland is now part of the second birth of Bellevue Island where new homes rise in the place of the early cottages.

Five

OTHER ISLANDS ON LAKE ORION

This postcard view shows the placidity for which Lake Orion was known in its largely undeveloped state in the early 1900s. Lake Orion offered urban visitors a peaceful excursion on the calm of its waters and a quiet stay on its wooded shores. Travel writers referred to it as "a gem among the inland lakes of Michigan" where "21 islands sleep like so many emeralds upon its shining surface." Causeways have connected some of these islands to the mainland over the years, but a graceful shoreline continues to enhance Lake Orion's aesthetic appeal. Including its islands, there are 18 miles of shoreline that surround the lake body of over 500 acres. (Courtesy of Paul A. Bailey.)

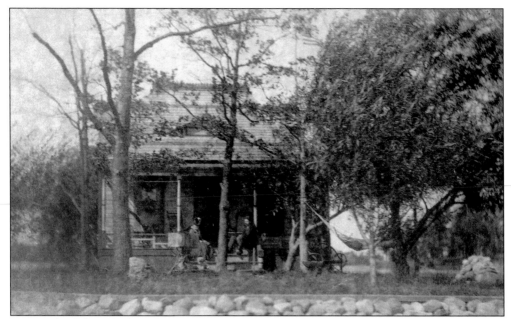

Squaw Island dates back to the origins of the village when the island was still connected on the north by a land bridge to the mainland. In 1832, a group of Native Americans stopped at the sawmill in the village and partook of whiskey offered by a mill worker there. In order to prevent violence, the squaws took the weapons and retreated to the site of Squaw Island where they camped overnight. The mill was set afire that night by the visitors, but the mill worker credited the squaws for saving his life and named the high ground in their honor. This two-story cottage (above) was built on Squaw Island in the 1880s by A. P. Backus of Detroit as a summer home, surrounded by a natural stone break wall. (Courtesy of the Northeast Oakland Historical Museum.)

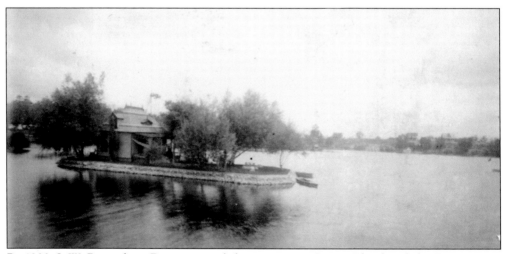

By 1900, J. W. Berns from Detroit owned the cottage on Squaw Island and the *Detroit News* Sunday magazine wrote in 1905, "Perhaps the most remarkable residence at Lake Orion is that of J.W. Berns. The little house is built upon what is known as Squaw Island. Tall trees of willow wave near the porch and fling their shadows upon the water. A narrow pier runs out into the lake. And there the Berns family spend their summer days like Robinson Crusoe on an island of their own."

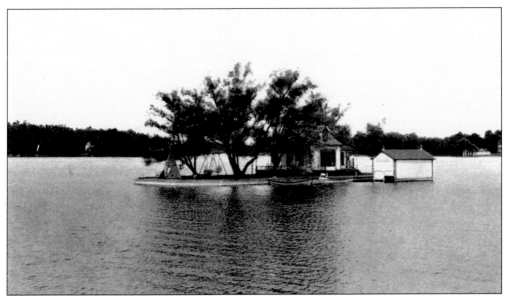

By the 1920s, a boathouse had been built on the island when owned by Detroit automobile dealer Jerry McCarthy and a tepee erected presumably for display (above). Helen Shrank bought the island for her family in 1937, after which it was sold in 1955 to Fred Caldwell, who then had the deteriorating cottage and boathouse torn down. Today very little remains of Squaw Island due to erosion, and it may become Lake Orion's next sandbar. (Courtesy of Dale Philips.)

Originally known as Bradford's Island, in 1897 Sweet's Island was purchased by Rev. John Sweet, a prominent Detroit minister. He was one of the founders of the Assembly Resort Association in 1898, and his island became known as Sweet's Island. In 1961, it was purchased by the Lake Orion Boat Club. The original boathouse is still used by the Lake Orion Boat Club. (Courtesy of the Lake Orion Boat Club.)

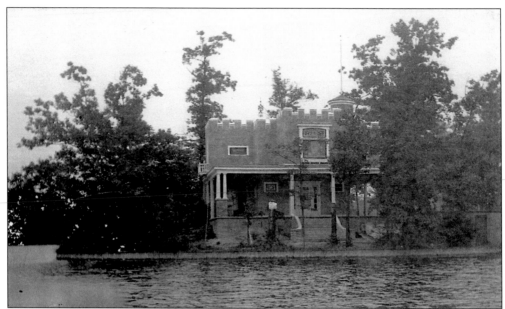

Romance Island, informally referred to as Castle Island, has a romantic and tragic history. In the 1880s, the island was purchased by the Dendel and Hartman families. Addie Dendel and Louis Hartman fell in love and built a cottage there in 1886. Tragedy struck when Louis Hartman was killed by a train that struck his car. Abandoned by the 1970s, the cottage was destroyed by fire. Today a chalet-style home occupies Romance Island and utilizes the original stone steps of the former "castle" cottage.

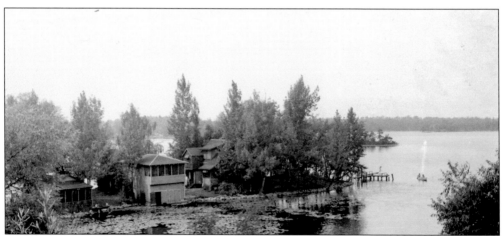

The Isle of Babette is named for Babette Evans of the husband-and-wife vaudeville team of Clare and Babette Evans. In the 1920s, the ever-romantic Clare bought the island and christened it Isle of Babette after his 16-year-old wife. They built several cottages on the island that are pictured here. They rented some of the cottages and hosted many show people at parties. The Great Houdini was allegedly among the guests. The original cottages are now gone, replaced by one large year-round home.

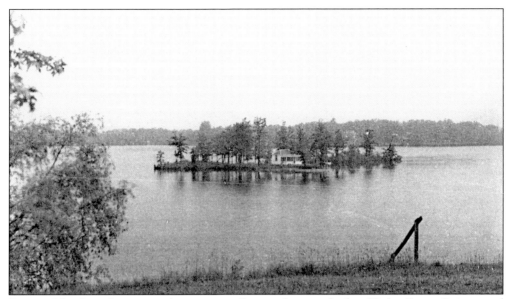

Preston Island is adjacent to the main sandbar in the west body of Lake Orion. It is named for the Preston family who purchased it in the 1920s; Don Preston and daughter Ruth and her husband Bill Trick built the two existing cottages on the island in the mid-1920s. The island was purchased by Eugene Jasunas in 1952 and became known as a "party island." Today one-half of the island and each of its cottages are under separate ownership and seldom used.

Dot Island, located just off the end of Shady Oaks Drive in the west body of the lake, was formerly known as Belle Isle. In the 1920s, a family by the name of Belle owned and summered on the island, and the original Belle cottage is pictured above. In 1985, interior designer Charles Jackson bought Dot Island and transformed the original cottage into a small, beautifully designed island home.

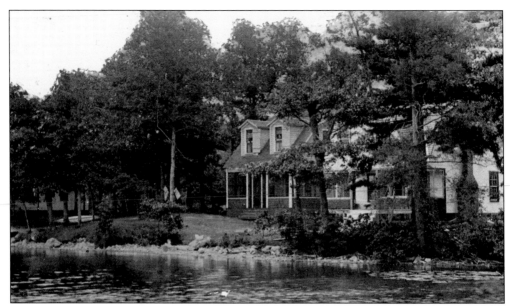

Armada Island sits between Sweet's Island and Heights Road on the east body of Lake Orion. There are only four cottages on the island, which were built in the early 1900s. Summer residents shared a well located in the middle of the island, along with a dock used by the passenger and delivery boats. The island is presumably named after families from Armada, Michigan, who initially used the island for camping. The four original cottages have been modernized, but their footprint on the island, as shown above in 1919, remains today as in this 1991 photograph of 490 and 482 Armada Island. (Below, courtesy of the Orion Township Library, Lakeside Cottage Project, photograph by Bradley Winther.)

Victoria Island is the third-largest island on Lake Orion, named by a summer resident of British descent, Col. Fred Cowley. It was first the YMCA Island, and then Three Acre Island. Some of the cottages were built in the early 1900s of precut lumber from the local lumberyard and moved in sections over the ice in winter. This cottage, Shady Dell (center), is a well-preserved example of the approximately 12 Victoria Island cottages. (Photograph by Lori Grove.)

In the early 1900s, Pine Island and adjacent properties on the mainland were owned by the Kunz family, proprietors of a successful jewelry business in Detroit. This area is still known as the Kunz subdivision. Frank Dunaskiss purchased the island and 13 acres from the Kunz family in 1947–1948. The main house on the island has since burned, but the Dunaskiss family continues to own the island and some of the mainland property. Shown above is its wooden bridge and boathouse. (Photograph by Lori Grove.)

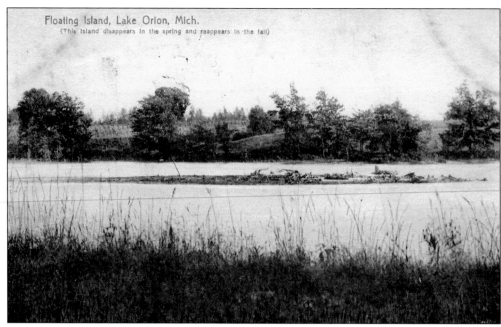

Floating Island, Lake Orion, Mich.
(This island disappears in the spring and reappears in the fall)

Nothing has been more curious to onlookers than the legendary "floating island." It was first noted around 1887, after which it rose to the surface annually at the middle of August and disappeared by the middle of March. The 300-foot-long island is located in the cove south of the Park Island Bridge. One theory is that trapped gas causes part of the lake bottom to rise, but it remains a mystery. It is shown in this postcard view around 1920.

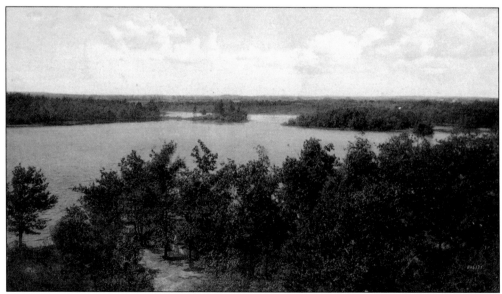

This postcard view of the "back lakes" shows the undeveloped shoreline of the west body of the lake, from a vantage point on Bellevue Island looking west. In the far background is the entrance to Spring Lake Bay (top, center). The west side of the lake was developed later than the east side of the lake, the latter having closer access to the amenities of the business district and resort on the lake's eastern side.

Six

SUMMER COTTAGES

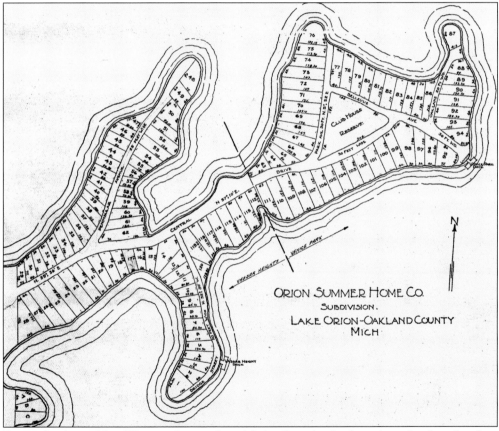

Resort developer John Winter, who purchased Lake Orion's islands and much of its shoreline properties in 1911, was responsible for the rapid and dense development of summer cottages around the lake in the early 20th century. His company, Lake Orion Summer Homes, subdivided the lake properties and constructed cottages "built to order in ten days." The footprint of this construction boom is evident today by the narrow 35-foot lots that radiate from the lake. The purchase of a lot included "a strip of submerged land . . . 40 ft. out and of equal width of said lot . . . for private use only and not for hire or gain." Above is a map of Vassar Heights and Venice Park, commonly known as Swiss Village, from the 1917 *Mathews Abstract Company's Books*, Pontiac, Oakland County, Michigan. (Courtesy of the Grove family.)

This large cottage (above, partly hidden by trees) and boathouse (above, right) were built for George Darling in 1884 opposite the Main Landing on Lake Orion. The cottage sits high on a hill with terraces leading down to a small cove in the lake. The property remained in the Darling family, for whom Darling's Cove is named, as cited on the postcard above, through the 1920s. Darling was in the wine business in Detroit, and he used the property behind the cottage for vineyards. A wine cellar behind the cottage extended 20 feet below ground, and the cottage and wine cellar remain today in original condition. In Darling's Cove, Venice Cottage (below) neighbors Darling's cottage to the south and is of the same era. It still exists at 162 South Andrews Street and looks today similar as when it was built.

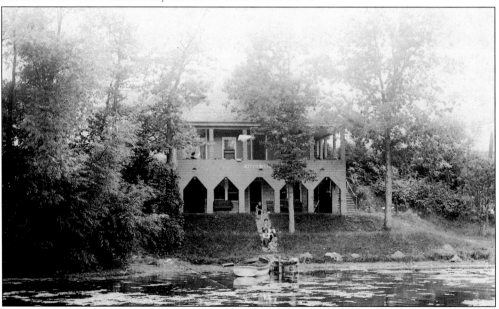

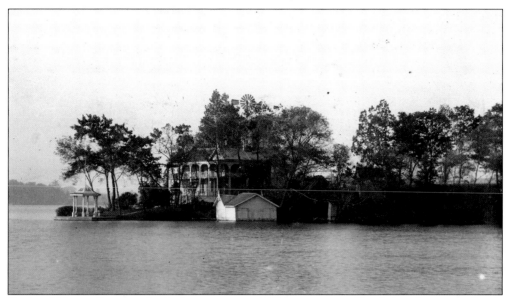

Fred and Emma Simmons built this cottage in 1881 on a point of land then known as Sandy Hook at the end of South Andrews Street opposite the Main Landing. The Simmons family summered there through the 1920s. There was a large boathouse below the cottage, a windmill behind the cottage that provided power for the well, a guesthouse, and a gazebo. The gazebo is all that remains of the original structures on Simmons Point today.

This cottage, located just off Lake Street, then known as Sagamore Hill, was owned by Mr. and Mrs. Claud Elkington from the 1920s until it was destroyed by fire in 1955. The Elkingtons owned the *Marilyn*, the sister boat to John Winter's launch the *Carolyn*. Mike Caldwell, who lived next to the Elkingtons' cottage, bought and restored the *Marilyn* in the early 1950s.

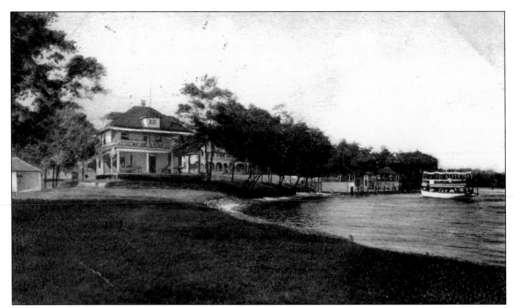

John Winter's summer home (above, also seen in chapter 4) was built on seven lots on a point of land called Point Comfort, later known as Winter's Point. Following his death, Evelyn Marquis's mother bought the summer home in 1941 after the house had been unoccupied for several years. At the time, the Point Comfort name was later still mounted above the door. The upstairs of the house was converted to an apartment for Evelyn's retirement, and the downstairs was used as a year-round home for Evelyn's niece Virginia, her husband Charles Viers, and their family. Evelyn claimed that they could "see the lake from every window in the house." Shown below, the house is essentially the same as when built by Winter in 1901. (Below, courtesy of the Orion Township Library, Lakeside Cottage Project, photograph by Bradley Winther.)

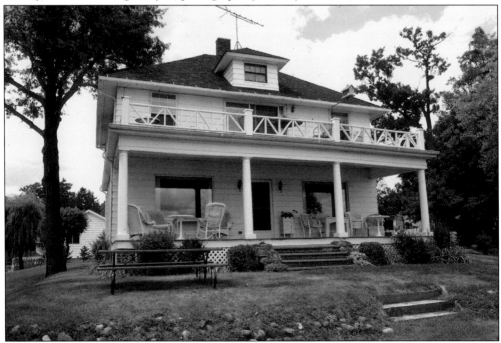

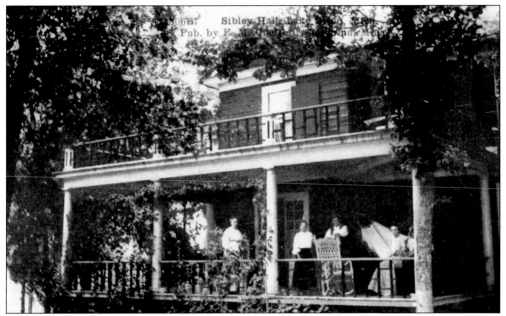

F. M. Sibley of Sibley Lumber in Detroit built this large Greek Revival summer home at 154 Grove Street in 1904, then known as Livingstone Point. In 1918, Robert and Nancy Stewart became owners and winterized and renamed it Bowdon Hall, where they lived year-round with their family until 1926. Summer residents mill about the south portico in the early 1900s (above). The south elevation of the mansion and the colonnaded front porch with Corinthian capitals are virtually the same in 1991, when owned by former village council president William Grube and his wife (below). (Above, courtesy of the Orion Historical Society, Steve Hoffman collection; below, courtesy of the Orion Township Library, Lakeside Cottage Project, photograph by Bradley Winther.)

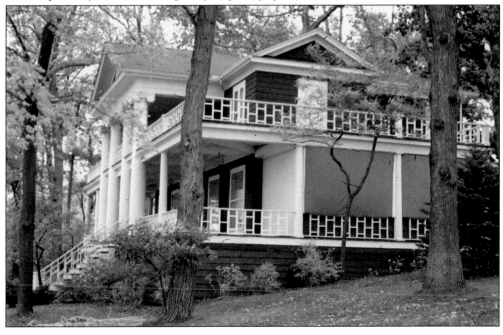

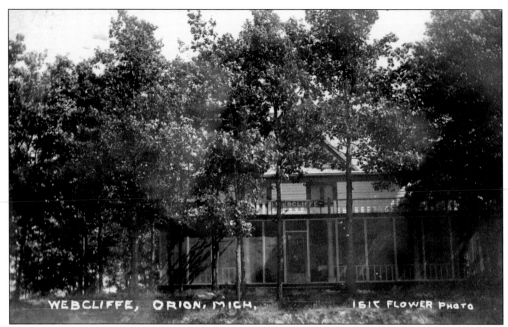

This sprawling summer home of three floors with a wraparound porch was built for Jarvis B. Webb around 1900. The Webb family owned the Michigan Fire and Marine Insurance Company, and their home in Detroit was at 1515 Chicago Boulevard, a fashionable Detroit neighborhood. This summer home, with a summer kitchen located in the back and a sweeping staircase inside the front door, was used to entertain many prominent friends of the Webbs. It was named Webbcliff and continued to be owned by the Webb family until sold in 2000 from the estate of Dr. Donald Vissher, a Webb descendent. It was demolished shortly after and the property divided into five lots for year-round homes on the lake. (Below, courtesy of the Orion Township Library, Lakeside Cottage Project, photograph by Bradley Winther.)

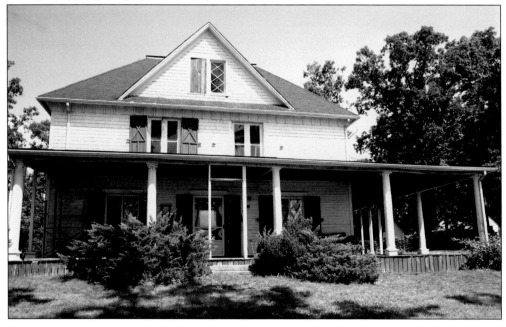

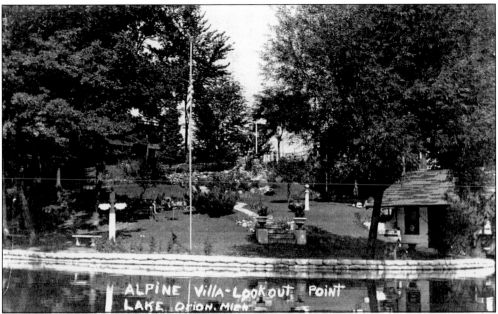

Alpine Villa (above) was built by Robert and Sofie Ewald in 1926, and this is how the Lookout Point appeared then, with the summer home on the hill and guesthouse called the Annex (right) at the shoreline. The point also had a large dock and dive platform (below), and the boathouse Noah's Ark was fancifully painted by their grandson Bobby with images of Noah and his animals. A bricklayer and stonemason by trade, their son Walter added many personal touches to Alpine Villa and the first cement break wall on the lake was built here for the Ewalds. According to Walter's wife Virginia, the Ewalds entertained 20–30 guests every weekend on this estate at 480 Cushing Street. Robert was a member of the Detroit City Council, and Ewald Circle in Detroit is named after him.

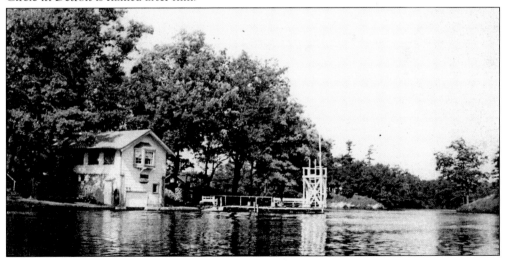

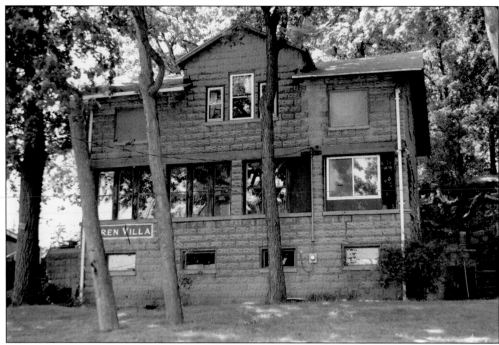

Avren Villa (above) and its sister cottage to the south Graystone (below) are large summer homes, constructed of molded cement block, built in the early 1900s on Heights Road. They are purported to have had the prestige of housing the major evangelists attending the summer chautauquas at Lake Orion. Avren Villa remains well preserved today. (Above, courtesy of the Orion Township Library, Lakeside Cottage Project, photograph by Bradley Winther; below, courtesy of the Orion Historical Society, Steve Hoffman collection.)

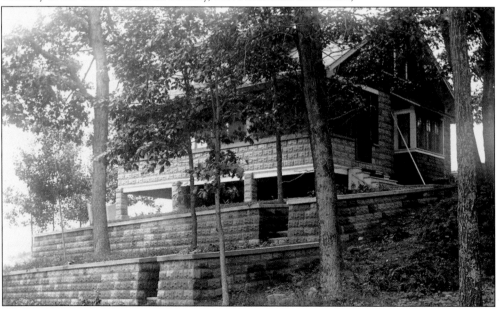

Milner Court is a complex of several cottages, and shown above are Morningside (center) and Cadillaqua (right). Pete Milner bought this property in 1900 and started building cement block cottages from a workshop on the property. Milner was the resort manager for John Winter and did much of the boat repair work. After his death, Mrs. Milner continued to rent these cottages into the 1950s. The boathouse shown below was part of Bannister Villa, the summer home of the Bannisters in 1913. The Milner home can be seen in the background on the right. Harry Bannister, their son, later married the famous actress Ann Harding. The main house and boathouse remain at 305 Lake Street today. (Above, courtesy of the Orion Township Library, Lakeside Cottage Project, photograph by Bradley Winther.)

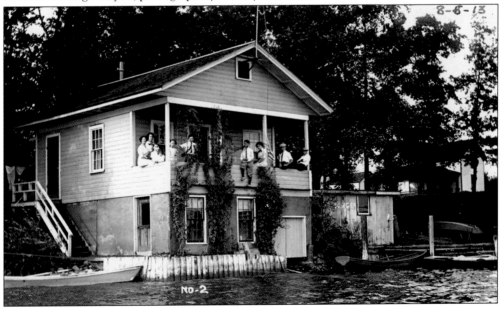

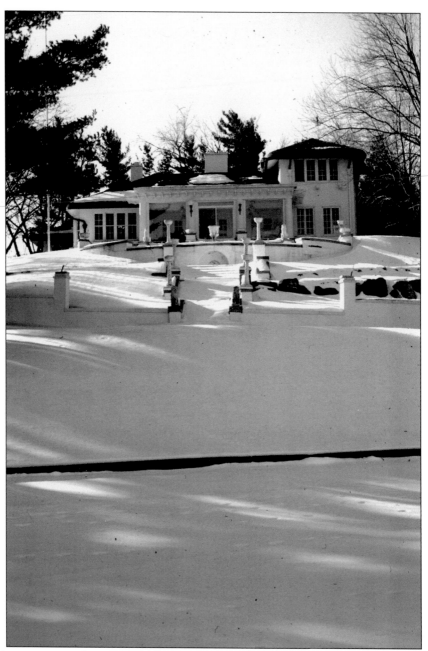

This elegant summer home was built for Christian Leidich in the early 1920s, in a Spanish Colonial bungalow style. Situated on several acres on the south shore of Lake Orion, several smaller cottages for friends and clients were scattered around the property. Leidich owned a travel agency that booked luxurious world cruises for wealthy clients in the Detroit area. The estate was known as Hill Orion, and Leidich died there in 1932; following that, the main house and three acres were bought by Mr. and Mrs. William Andrews in the 1940s. William owned the patent on the penny candy machine and manufactured them in a small basement factory on the property into the 1950s. The house remains well preserved at 850 Heights Road today. (Photograph by Lori Grove.)

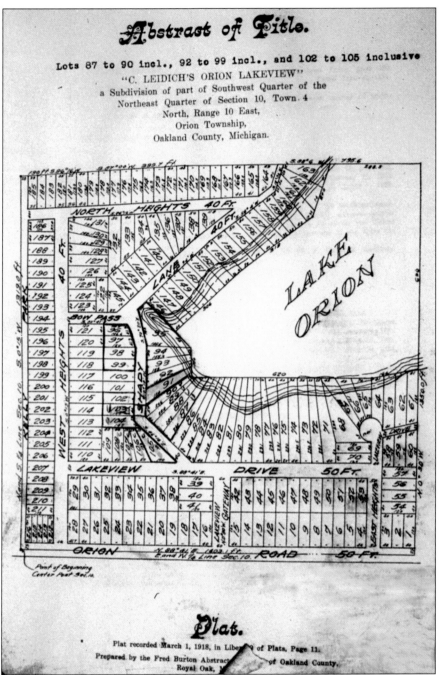

Abstract of Title.

Lots 87 to 90 incl., 92 to 99 incl., and 102 to 105 inclusive

"C. LEIDICH'S ORION LAKEVIEW"
a Subdivision of part of Southwest Quarter of the
Northeast Quarter of Section 10, Town. 4
North, Range 10 East,
Orion Township,
Oakland County, Michigan.

Plat.

Plat recorded March 1, 1918, in Liber 9 of Plats, Page 11.
Prepared by the Fred Burton Abstract of Oakland County,
Royal Oak, M

This densely platted area shows Leidich's Orion Lakeview subdivision and how lots were subdivided in tiers from the lakeshore. Small cottages built on the subdivided property included the cottage of Jack and Helen Schodowski at 798 King Circle, who recalled hearing "music from the mansion" during elegant garden parties hosted at the nearby estate (opposite page) when owned by the Andrews. According to the Schodowskis, the unpaved road of King Circle was formerly called Lakeview Street when they purchased their cottage in 1948. (Courtesy of Dawn Ramsay-Stuber and Hank Stuber.)

97

At 546 Shady Oaks in Leidich's Orion Lakeview subdivision, this large bungalow cottage is closed up for the winter. According to Geraldine Ramsay, who purchased the cottage from Christian Leidich in 1939, it was one of four cottages the Leidichs used to host their European visitors and other guests. Now owned by daughter Dawn Ramsay-Stuber with husband Hank, it is still used as a summer cottage by the Stuber family, who call it Shady Shack. (Photograph by Lori Grove.)

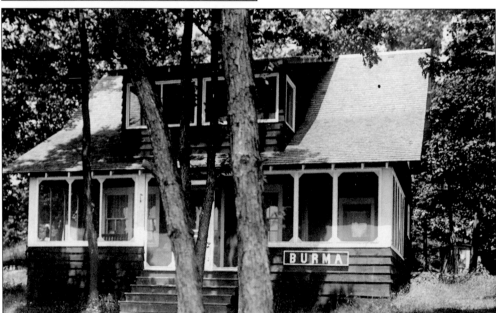

The Burma cottage sat at the bottom of a long decline to lake level on Oak Lane off Central Drive next to the Venice Park boat landing. Large oak and mulberry trees, abundant in this area, wooded the lot right up to the lakefront. The original structure has been remodeled in the recent past. (Courtesy of the Orion Historical Society, Steve Hoffman collection.)

John Mette claimed to have blazed the trail through this stand of pines to the site of his cottage at 938 West Pine Tree (right) in 1900. Used as a summer residence, he would stay unusually long, through to Thanksgiving every year. From each side of the cottage, a set of concrete stairs descended to the lake and a bench where he would sit and watch evening sunsets. His ashes are now buried there. A hand-built fieldstone fireplace adorned his simple craftsman dwelling, and handmade fanciful birdhouses ornamented the property when sold from his estate in 1990–1991. In the same vicinity, wooded by pines, this cottage at 853 Dollar Bay Road (below) was built in the 1920s on two lots fronting Dollar Bay and was kept in the Groen family for two generations until 2005. (Photographs by Lori Grove.)

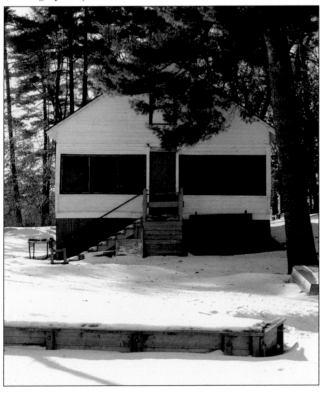

Names of cottages referred to the character of a cottage and its surroundings, or simply expressed the whit and whimsy of the cottage owner. Each name was unique, such as the All Well Cottage, 4-EEEEs, and Tarry A While. The summer cottage Norwood (above) was formerly located on North Shore Drive. When the electric and telephone companies came through the Lake Orion area, street numbers were assigned to each cottage, and the need for posting cottage names diminished. The porch, with a screen of thin vertical wood slats extending from the decking to the ground, appears deteriorated in 1991 (below) when less than 50 summer cottages remained on the lake. (Below, photograph by Lori Grove.)

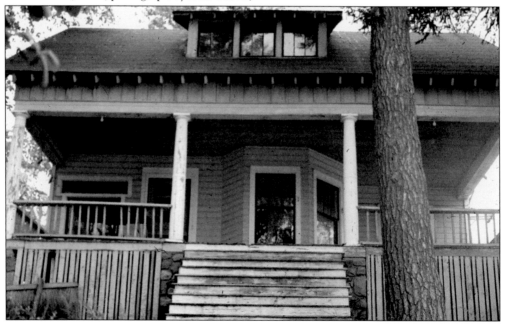

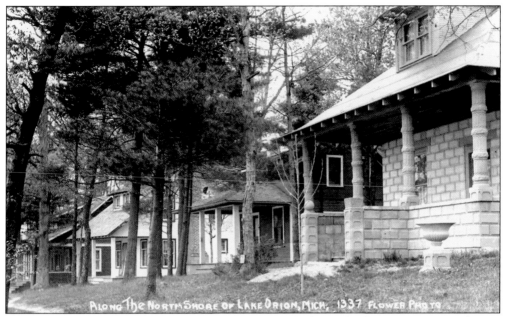

This row of cottages (above) were built along the north shore of Lake Orion, presumed to be along what is now North Shore Drive. In the foreground is a bungalow cottage of concrete block, rusticated to resemble stone, with molded concrete columns supporting the roof. Forming concrete in molds to resemble stone was very popular between 1900 and 1915. On the back of the photograph the owner wrote, "This is our cottage looking north." A few years later, the open porches on all these quaint cottages are encased by metal screening (below), before framed screening was readily available. In this wooded stretch, the metal screening was primarily installed to protect summer residents from mosquitoes and other flying insects. (Courtesy of the Orion Historical Society, Steve Hoffman collection.)

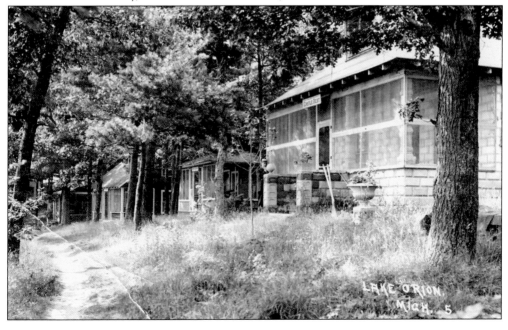

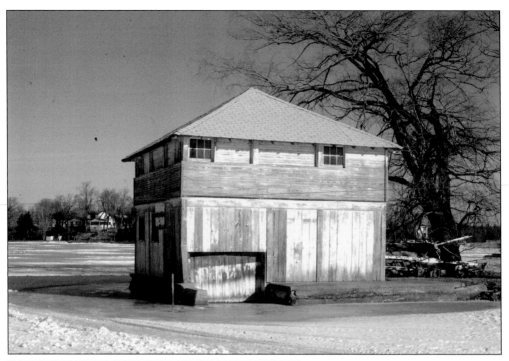

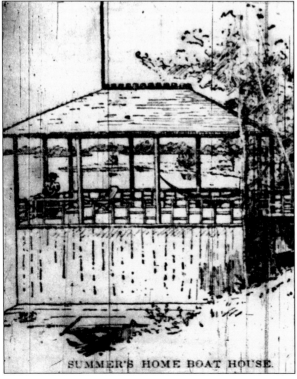

SUMMER'S HOME BOAT HOUSE.

Boathouses sat out over the water on piers or were constructed into the break wall with a boat well, as shown here at the end of West Point (above). For decades, this boathouse has served as a beacon for the adjacent sandbar west of its embankment. To the left, in a c. 1900 *Sunday News Tribune* article of the *Detroit News*, a "summer's home boat house" illustrates a rooftop being used on Lake Orion as an open deck. According to late resident Bill O'Brien, who grew up with a summer cottage on Lake Orion where he eventually lived year-round, "all the places had boat houses." Jimmy Hoffa, who had a cottage on Square Lake, kept his inboard boat in a boathouse on Lake Orion that belonged to home owner Paul Allen, former head of the Riggers Union. (Above, photograph by Lori Grove; left, courtesy of the Detroit News.)

The plans for this unusual summer cottage on Lake Orion (above) were sketched out on a piece of Earl's Feed Store stationary (right) and constructed over a boat well at 560 Barron Drive in Venice Park. Formerly named Hollow Crest, it was built by a medical doctor, "Doc Rund," in 1947 as a summer residence and in 1976 became the year-round residence of Harrison Dornton, with minimal remodeling. It has since been extensively remodeled under different ownership. Late resident Bud Schaar made many improvements to cottages around the lake and described them as being "just a place to sleep with a front porch." About the smaller cottages on the lake, he quipped, "They were very primitive and they was cheap." (Above, photograph by Lori Grove; right, courtesy of the late Harrison Dornton.)

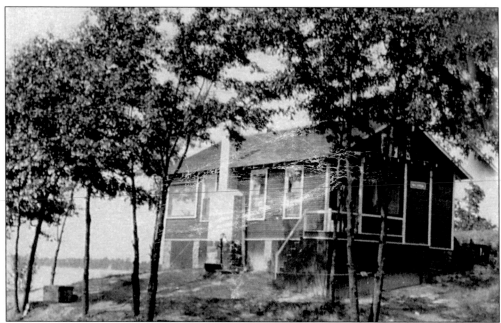

One of the last remaining summer cottages on Lake Orion is the Waconda at 352 Heights Road (above), built in 1916 by George and Irene Fuller for their family. It is owned today by their daughter Helen, who has used it to summer with her family and grandchildren. Helen has likely been summering at Lake Orion longer than any other summer or year-round resident. In a 1991 interview about summer cottages, she explained that she kept the original cottage because she wanted something for her family that they "could remember with love, and that's why it doesn't change." Her father named the cottage based on a novel about a Native American story, and it means "Great Spirit of the Waters," as it remains named today (below). (Above, courtesy of Helen Fuller-Goerlich; below, courtesy of the Orion Township Library, Lakeside Cottage Project, photograph by Bradley Winther.)

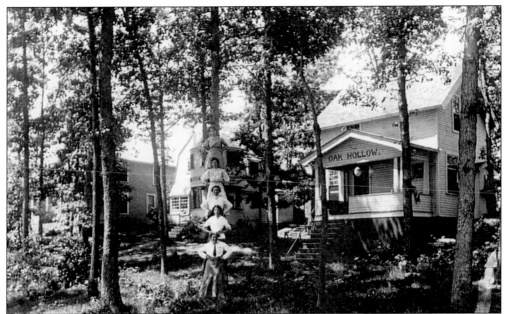

A postcard shows the Oak Hollow and another summer cottage on Lake Orion at 310 and 318 Bellevue Road in 1912 (above). The first Lake Orion Boat Club built a clubhouse in 1914 on Jossie A. Street (below, now North Shore Drive), north of where West Flint Street ends at the lake. It hosted dances on Saturday nights, and the former Lake Orion Boat Club building became the Orionark Dance Hall in the 1930s, which was operated by the Unger family. Babe Ruth made several visits to Lake Orion as the houseguest of Irvine J. Unger, player and manager of the Lake Orion baseball team. Ruth appeared as the guest speaker at a team banquet held at the Lake Orion Hotel, following which he presented Unger with one of his home run bats. In the 1940s, part of the dance hall became the Orionark Cottage used by the Ungers.

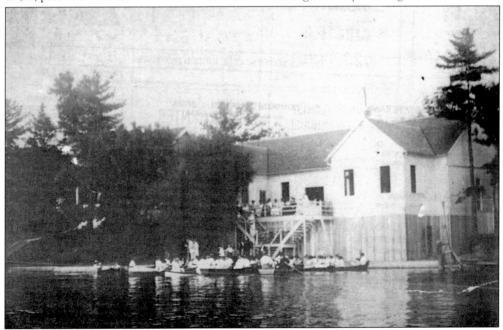

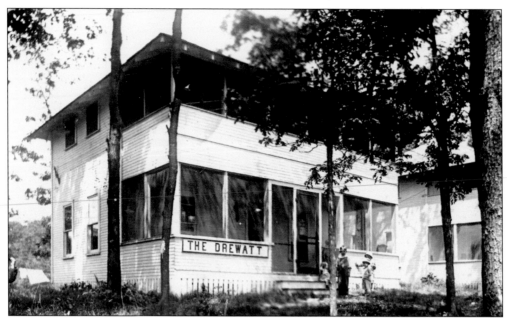

On the narrow peninsula of Bridge Street in Swiss Village, cottages were built with close access to the lake in both the front and back. This cottage, originally called the Drewatt with a twin cottage called the Annette next door, was built in 1914 and bought by Carless and Juanita Hibbs in 1950 for their family. Since 1972, it has been owned by their daughter Carol and her husband Tom Hudson. Tom proposed to Carol under a tree on the bay side, or back, of the cottage. In front, a rope swing suspended from a large oak tree over the lake was a local attraction. Below, Juanita (right) and sister-in-law Linda Hibbs take a break atop their car from ice-skating in the 1950s. (Above, courtesy of the Orion Historical Society, Steve Hoffman collection; below, courtesy of Dennis and Juanita Hibbs.)

Minnie Laura and Delmar Bronson built this cottage in 1915 at 135 Bridge Street from a "Sears kit home" of precut lumber and a design offered by Sears, and it was used by four generations of the family. The cottage passed on to their daughter, Ethel Bronson Addis, who passed it on to her daughter Minnie Merle and her husband Lee DeLano. Their daughter Janet and her husband Terry Brewer owned the cottage and claimed that "everything happened on the front porch," such as playing cards, eating meals, and entertaining friends. In this view, the porch screens are covered with plastic. With its original design intact, the kit cottage was demolished in the early 1990s under different ownership. (Photograph by Lori Grove.)

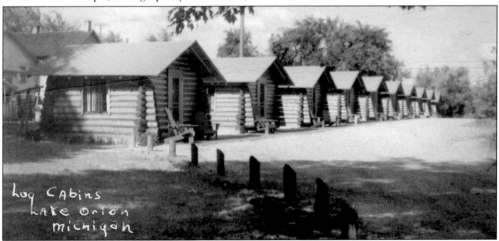

Cy McCaughna built his private resort, Canandaigua Park, on the lake at the corner of Heights Road and M-24 in the late 1930s. "Ten, all-modern heated log cabins" were advertised for overnight or weekend guests. McCaughna sold Canandaigua Park to George Kirn in the late 1940s, and it continued to be run as a resort into the 1950s as Kirn's Rustic Cabins. (Courtesy of the Orion Historical Society, Steve Hoffman collection.)

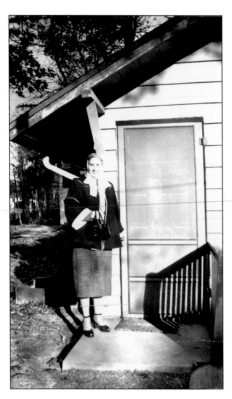

Central Drive curves east from Indianwood Road and opens onto high ground above lake level, thus earning its informal name—Swiss Village. Inspired by the hills, many summer cottages were built on its sloping grounds in Swiss chalet style by Harold H. Weimeister, who bought properties directly from Lake Orion Summer Homes Company in the late 1920s. Helen Grove (mother of coauthor Lori Grove) stands beneath the characteristically deep eaves outside the front door of her newly acquired Swiss Village cottage in 1956. Husband Boyd was referred to as the "Mayor of Swiss Village" by neighbors there. (Courtesy of the Grove family.)

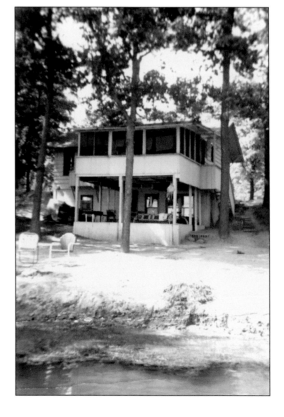

This two-story porch on the front, or lake level, view of the Groves' cottage in 1958 gives it the appearance of being large when the interior living space was only 30 feet by 30 feet. The screened-in upstairs porch served as an extension of the kitchen where all meals were served in the summer and provided extra sleeping space for frequent visitors. The Swiss chalet–style cottage was built in the late 1920s and moved onto a cement block foundation sometime later. By enclosing the porches, Helen and Boyd Grove converted the cottage into a year-round home in the 1970s, as it remains today. (Courtesy of the Grove family.)

The Grove family is shown here, with a crew of neighbors from their block in Detroit, in front of their cottage around 1959. From left to right are (first row) Nancy Bryant, Catherine Saul, Jeanette LeBeault, Lori Grove, Sue Burrell, Connie Grove, and the Grove family dog Peppy; (second row) John LeBeault, Jim Saul, Henry Lebeault, Gary Grove, Helen Grove, Rita Saul, and Emma Jean Lebeault; (third row) Boyd Grove, Spencer Saul, and Robert LeBeault with son Philip on his shoulder. (Courtesy of the Grove family.)

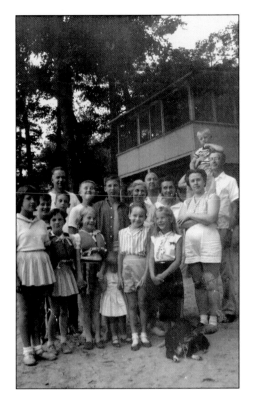

Genevieve "Gene" Raines's former cottage in Swiss Village is shown in the background alongside a sloping hill that was also her property. This hill was a favorite for winter sledding by neighboring sisters Connie and Lori Grove (coauthor is in sled), who pose in front on the ice in 1957. Gene and husband Roy, a founding member of the Lake Orion Boat Club, made improvements to this Swiss chalet–style cottage that included the cement stairway on the hill and retaining walls constructed of fieldstones they collected. (Courtesy of the Grove family.)

Frank and Blanche Gortat bought their cottage in Swiss Village at 269 Peninsular Street in 1946 when Central Drive was still a gravel road. Frank continually improved the cottage, which eventually became their year-round retirement home. Built into the side of a hill, the original cottage, shown here with enclosed upper porch, was called Chalet of the Crest and was one of the highest points in Swiss Village. (Courtesy of Jerry Gortat.)

Here David Charles Ingoglia (right) and a friend stand between three cottages on Bridge Street in 1966. To the right is the newly remodeled and aluminum-sided cottage that is now Ingoglia's year-round home. To the left is the first cottage purchased by his parents, Mary Ann and Dick Ingoglia, in the mid-1950s. Behind them, partially shown, is a third cottage that was built on a narrow strip of land across the street. (Courtesy of David Charles Ingoglia.)

Dennis Hibbs sits in the family boat in 1958 as if he is a seasoned boat operator at the age of four. Behind him, a string of cottages curve along this bay on the west side of Bridge Street, including one with a prominent screened porch protruding above the shoreline (center). This cottage sat directly on the shore and was later removed by the Ingoglia family to expand the rear cottage behind it, which shared the lot. (Courtesy of Juanita and Dennis Hibbs.)

Here the Grove girls sunbathe in 1958 on the same day as shown above on the dock owned by Gene and Roy Raines. Ardis Wisner, late summer resident on Longpointe, referred to this bay as Stump Bay for the fallen logs and tree stumps submerged on the bottom. From left to right are Helen Grove, Lori Grove (coauthor), Connie Grove, and Judy Grove-Purewal. (Courtesy of the Grove family.)

Gale "Al" and Christine Dinsmore bought their cottage at 602 Cushing Street in 1963 on the bay around which Indianwood Road curves. Here their daughters, from left to right, Karen, Nancy, Donna, and Marlene, sit on a raft at the end of their dock in 1963 with friend Anna and family dog Tiger. Across from them in this bay is the Lake Orion Public Access site (not shown) created as a fishing access site in the 1940s. A public meeting filled village hall in 1977 when improvements proposed by the Department of Natural Resources substantially increased the site's capacity for boaters. As a result, the Lake Orion Lake Association was organized in 1978 to monitor lake use issues, and Department of Natural Resources plans were reduced in capacity and built in 1980. As testimony to the signposts at township borders (below), Lake Orion remains a popular boating destination every summer. (Above, courtesy of Glenn Rohder; below, photograph by Lori Grove.)

Seven

BOATING ON THE LAKE

Boats played an important role in Lake Orion's evolution as a major summer resort. The *Little Dick* was the first passenger launch to operate on Lake Orion in the 1870s. It was steam powered and owned by E. R. Emmons, who named it after his son Richard. It is shown above at the Main Landing, now Green's Park. In 1884, a new steam excursion yacht purchased by the Orion Park Association replaced the *Little Dick*. The new yacht was 40 feet in length with a 9-foot beam and accommodated 100 passengers for excursions around Lake Orion. The association used the *Little Dick* for passenger boat excursions as the early operators of the Lake Orion resort.

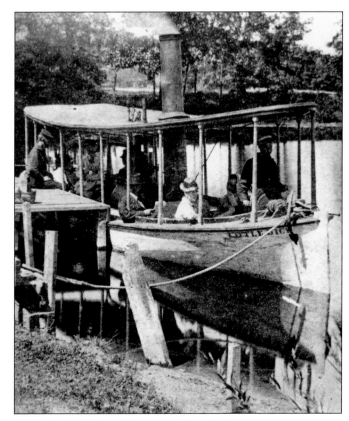

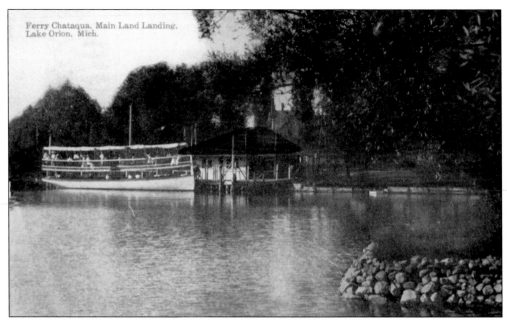

Ferry Chataqua. Main Land Landing.
Lake Orion, Mich.

In the early 1900s, a fleet of eight large boats plied the waters of Lake Orion, hauling everything from freight to groceries to passengers and the U.S. mail. The largest of the excursion boats on Lake Orion was purchased by John Winter, the resort developer, in 1901 and christened the *Chautauqua* (above). It was a double-decker that could accommodate 300 passengers. The upper deck could be partially or completely covered, and on weekends an orchestra played on board to which passengers could dance. After the *Chautauqua* nearly capsized in a strong wind while trying to dock at the Bellevue Hotel, it was rebuilt in 1915 with a widened beam and entrances made level with the docks. It was renamed the *City of Orion* and is shown below leaving the Park Island dock. (Above, courtesy of the Orion Historical Society, Steve Hoffman collection.)

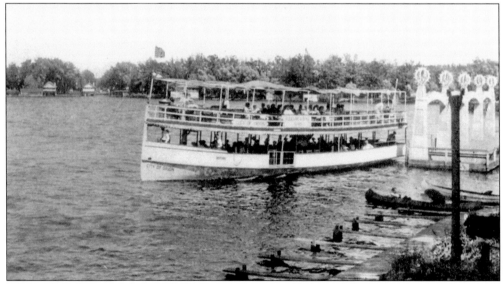

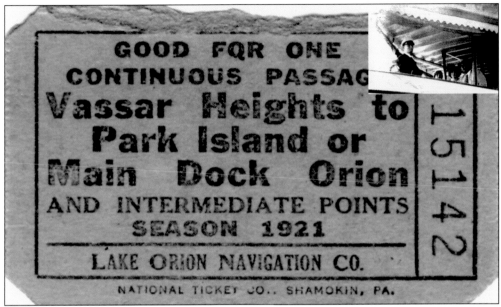

GOOD FOR ONE
CONTINUOUS PASSAG
Vassar Heights to
Park Island or
Main Dock Orion
AND INTERMEDIATE POINTS
SEASON 1921
LAKE ORION NAVIGATION CO.
NATIONAL TICKET CO., SHAMOKIN, PA.

15142

This ticket could be used on the *City of Orion*, or any of the passenger launches during the 1921 season, for lake travel between Vassar Heights (in Swiss Village), Park Island, or the Main Dock in Orion. For 10¢ one could ride around the lake all day on the *City of Orion*. The *City of Orion* was captained by Albert Victor Foisey (inset), whose former house at 302 South Broadway Street looks today as it did when built in the 1880s.

A 1920s brochure advertising Lake Orion featured these large passenger launches, with the double-decker *City of Orion* in the far background passing Simmons Point. Center is the launch *Promise*, which had a fixed roof and was enclosed by windows that could be opened. Left is the open launch with a canopy roof *Pleasure*. These launches carried approximately 40 passengers around the lake to the various landings and docks, when few visitors had boats of their own.

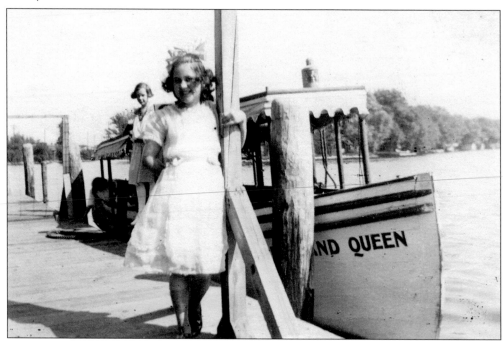

Esther Belles-Ingram (mother of coauthor James E. Ingram and great-niece of resort developer John Winter) poses in the 1920s on the dock beside the *Park Island Queen*, one of the smaller passenger launches on Lake Orion. This launch and the *Silver Spray* were piloted by John Deer. The passenger launches had designated routes all around the lake. If someone wanted to be picked up at one of the docks, they would raise a flag as a signal to the launch pilot.

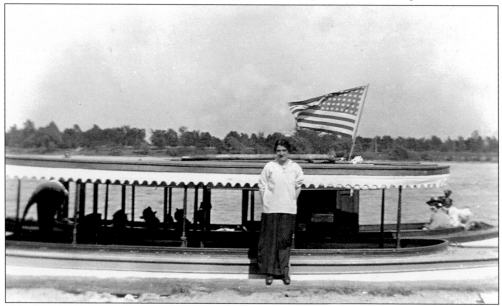

Another of the smaller passenger launches on Lake Orion was the *Pastime*, piloted by Lee Anderson. With the decline of Lake Orion as a summer resort, the *City of Orion*, as well as some of these smaller passenger launches, were sunk and used for fill at an embankment on the west shore of Oak Lane in the 1930s.

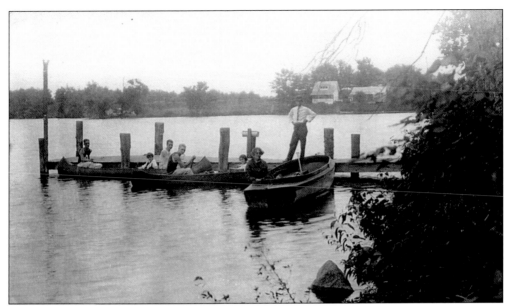

The South Shore Landing dock was located on what is now Heights Road, just opposite the Lake Orion Boat Club island. These large docks, located at intervals all over the lake, were used by the passenger launches as well as other boats, as seen in this picture. Vestiges of some landing docks were still evident around the lake as late as the 1960s.

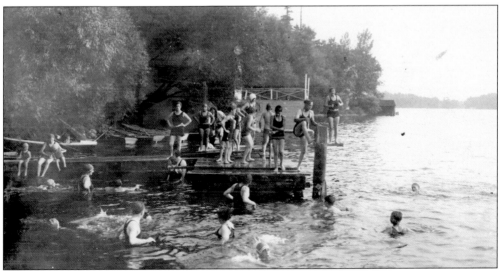

Cole's Dock at the foot of West Flint Street in the village of Orion was used extensively for swimming by those staying in cottages or hotels not directly on the lake. Some of the other prominent docks around the lake were the Sunset Dock, the Longpointe Dock, the Kelly Dock, the Locust Point Dock, the Venice Park Dock, the Vassar Heights Dock, and the Orion Heights Dock.

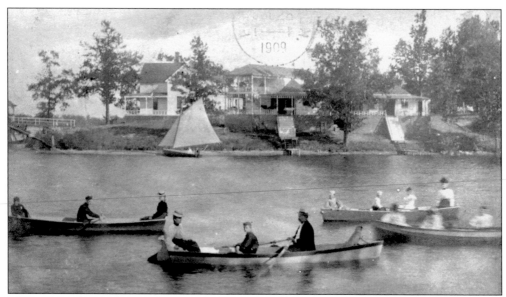

This picture shows the popular boating activity on Lake Orion in the early 1900s, when dress standards were formal even at a summer resort. This is a view south along the east shore of Bellevue Island, taken from Longpointe. At that time, Lake Orion was a popular summer resort for young single women and young single men. One 1915 Lake Orion postcard says, "Does this girl look good to you? If not, there are many others here. Yours, L.C.T."

The more affluent summer residents had their own launches on Lake Orion. John Winter's launch was called the *Carolyn* and is shown above in drydock in 1955 with the wife of Earl Bliss Jr. Winter was usually chauffeured in this launch by a servant from Point Comfort, his summer home on Bellevue Island, to his office at the Main Landing. In the 1950s, Earl Bliss Sr. used the *Carolyn* to go from his home to his job at Lake Orion Lumber Company.

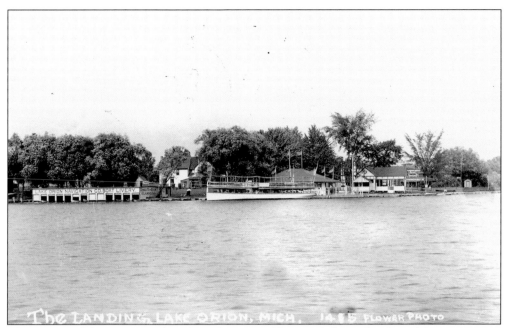

This picture of the Main Landing (now Green's Park) in 1916 shows the *City of Orion* excursion boat in the center, with the Lakeside Café on the right. On the left is the Lake Orion Navigation Company Boat Livery, which was one of John Winter's enterprises. It rented in excess of 100 boats, including canoes, canoes with outriggers, rowboats, and launches with one-cylinder motors. The Lakeside Hotel can be seen in the background of the livery.

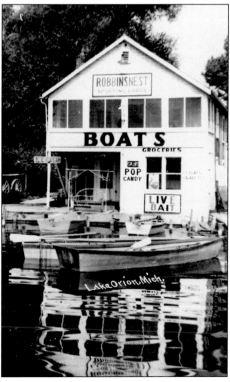

Mr. and Mrs. Robbins ran a boat livery and a small grocery on Lake Street in the 1950s and 1960s called Robbins Nest. They lived above their store, and east of them was a string of boathouses built in the early 1900s. The livery was operated by Bell's Boat in the 1930s and early 1940s. Harold and Harriet Roberts operated Roberts Rendezvous here until Bob and Thelma Spearing bought the livery, boat docks, and store in 1974 and operated Spearing's Lakeside. In 1987, they sold to Scott and Cathy Campbell, who continue the business today as part of Orion Marine.

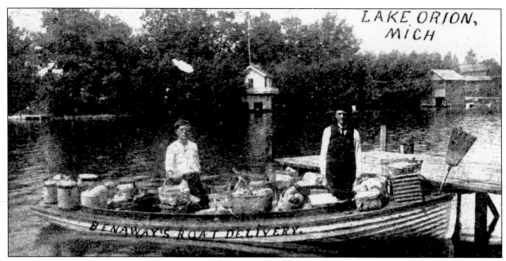

In the early part of the 20th century, many of the local merchants delivered their goods by boat. Benaway's Boat Delivery is pictured on this postcard loaded with groceries to be delivered to various cottages. Another working boat referred to informally as the "stink barge" collected canisters from the outhouses around the lake that was required in order for Lake Orion to maintain its advertised reputation as "A Clean Resort for Clean People." (Courtesy of Marie Shoup.)

The Galloway Market was located at 623 Central Drive in Swiss Village and had eight boat slips for boaters to moor and shop on Lake Orion from the 1950s into the 1970s. This small grocery store was one of three stores on the lake for summer residents without access to cars. Hugh Galloway was on the village council when one of Swiss Village's steepest hills along the roadway of Central Drive was modified to make it more passable for vehicles year-round.

Lake Orion has the distinction of introducing the first inland lake marine postal service to the United States in 1905. This 19-foot Truscott naphtha launch, shown above, was initially used to deliver mail on Lake Orion. Tuttle's Point (now Pelton's Point) is in the background, and Harry W. Bickfort is likely at the helm. Mail was delivered by boat during the summer months to mailboxes mounted on the ends of docks through 1952. Rather than street numbers, mail would be addressed to cottage names such as Old Homestead, Venice Cottage, Ten Oaks, Point-O-Pines, Stumble Inn, and Oakhill, to name only a few. Below is Dick Stephen delivering the mail in his U.S. mail boat in the late 1940s. (Below, courtesy of Ed Roberts.)

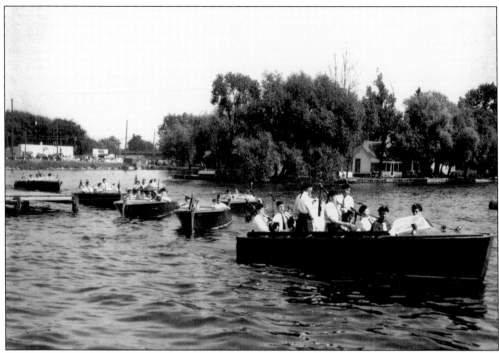

Boat racing has historically been popular on Lake Orion, and both amateur and professional races were sponsored by the Lake Orion Boat Club from the 1930s into the 1970s. This group of Chris-Craft and Century inboards (above) raced on Lake Orion in the 1940s and 1950s. The lead boat carrying a group of bagpipers in a summer boat parade is a 1930s Garwood driven by owner Mac McComb. The Detroit Championship Hydroplane Races under the sponsorship of the Lake Orion Boat Club were also held on Lake Orion in this period (below). From the shores of Lake Orion, over 4,000 people watched as 30 drivers demonstrated their skills in outboard motorboat racing. (Below, courtesy of the Orion Historical Society, Steve Hoffman collection.)

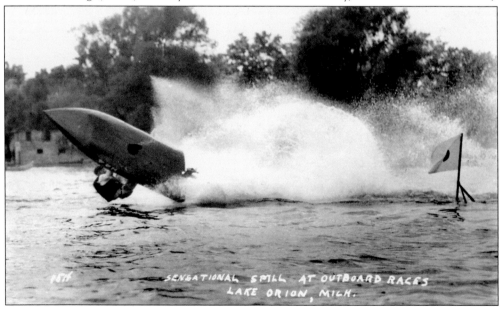

The Lake Orion Boat Club sponsored sailboat races on Lake Orion from the 1930s into the 1990s, and in the early years, a variety of class boats sailed its waters. A Canadian boat, *Wayfarer*, dominated in the 1950s and 1960s, and in the 1970s, the Flying Scott become the dominant class. Recreational sailing has been an enduring activity on the lake. George and Irene Fuller are seen here sailing on the *Grace* in front of their cottage in 1924. (Courtesy of Helen Fuller-Goerlich).

Bud Schaar claimed that his boat was one of the first fast boats on the lake, an outboard motor mounted on a 16-foot boat that went 25 to 30 miles per hour. Shown on the left in his boat with friend Harold Ingram (father of coauthor James E. Ingram) in the 1930s, they used to "surfboard" behind it on an old wooden door. Bud claimed that the lake "was like a big neighborhood out there" and that "Lake Orion was the hot spot."

A Sea Ray Boat Company catalogue featured a new speedy outboard pushing past coauthor James E. Ingram in his teal class sailboat on Lake Orion around 1965, with Point Comfort in the background. C. N. Ray started his Sea Ray Boat Company in neighboring Oxford in the 1960s where they manufactured boats until the 1980s. In their early years, the dealership supplied a boat to the Lake Orion Village Police for patrol on the lake.

Here a powerful MasterCraft pulls six water-skiers in front of Point Comfort by Bellevue Island on Lake Orion in 1998. Dave Hudson, boat owner and competitive skier on the trick ski in the left outside lane, is a resident on neighboring Long Lake, which has one of the longest-standing sanctioned slalom courses in the state of Michigan. Fellow skiers beside him include his wife Debbie and friend Brian Daenzer. (Courtesy of Dennis and Juanita Hibbs.)

The tradition of the Fourth of July boat parade began in 1888 when three of Lake Orion's pioneer resorters, L. W. Muller, George Darling, and William Thayer, offered prizes for the most beautifully decorated and illuminated boats on the lake as part of the day's celebration. This annual affair became known as Venetian Night. In the evening, cottages vied with each other in illuminating their grounds. The big attraction was the illuminated parade of floats, launches, rowboats, and canoes. They were elaborately decorated and lit with Japanese lanterns, making a brilliant, spectacular display. Above is a newspaper clipping of two of those decorated launches. The Venetian Parade remains a tradition to this day, and Flair Night now accounts for the illuminated effects. Below is Bill Davis, commodore of the Lake Orion Boat Club, escorting the queen candidates in his Chris-Craft for the Venetian Parade on the Fourth of July 1951. (Below, courtesy of Jerry Gortat.)

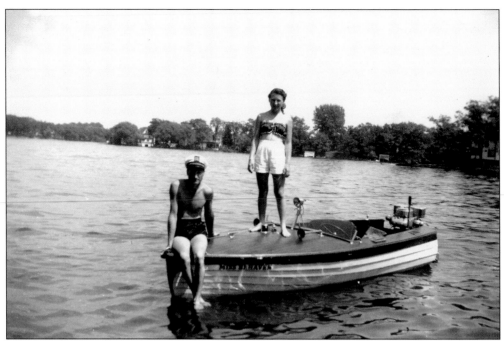

By the mid-20th century, wooden boats used on the lake included the wooden lap strake boat (above) with owner Carless Hibbs and daughter Carol on the hull of the *Miss Behaven*. In this east view on the lake, Longpointe is directly behind them, and Victoria Island is on the right. Commonly made by Thompson Boat Company, these boats were typically powered by 20–50 horsepower motors and superseded the old wooden launches of the 1920s and 1930s on Lake Orion. The sleek interior of an early wooden launch is shown below in a topside view of a contemporary replica. (Above, courtesy of Dennis and Juanita Hibbs.)

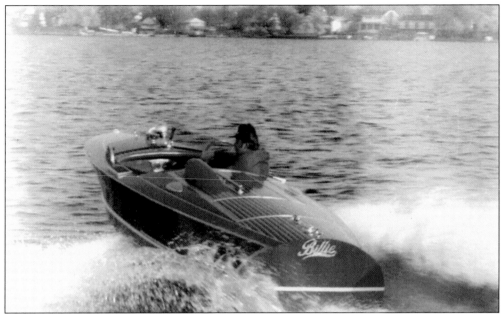

Jerry Gortat takes off in his 1939 Chris-Craft Special Racing Boat *Billie* in front of Park Island in 1983. The elegant, mahogany plank Chris-Crafts, named after their designer Christopher Columbus Smith, were manufactured in Algonac with their main plant on the St. Clair River. The visionary boat builder and racer applied Henry Ford production line techniques to his company and grew to be the largest boat manufacturer in the country by the mid-1900s. (Courtesy of Jerry Gortat, photograph by Scott Campbell.)

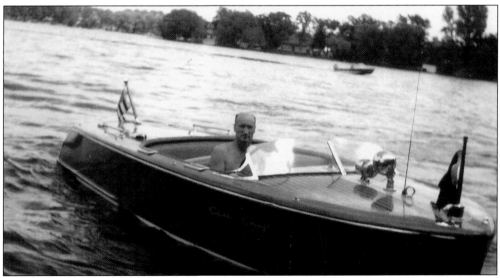

Carless Hibbs poses in his 1948 Chris-Craft Deluxe Runabout *NITACAR*, named by combining abbreviations of his and his wife Juanita's names, as he prepared to dock at his cottage on Bridge Street in the 1960s. In the distance, a smaller motorboat travels past, which was likely a Clyde outboard runabout then common on Lake Orion. Their molded plywood hulls were built by fishermen in Nova Scotia during the winter and shipped to dealers like Clyde Boats in nearby Detroit. (Courtesy of Dennis and Juanita Hibbs.)

In this view, looking south on the west side of the lake, the *Hel-Boy* carries a second and third generation of the Grove family as it cruises inside the bay by Romance Island. Helen and Boyd Grove personalized their 1957 Chris-Craft Cavalier with an abbreviation of their names when bought in 1958, and it has since provided decades of family fun, water-skiing, and many moonlight cruises on Lake Orion. It is now owned by James B. Grove II, who pilots the craft in 1996, with sister Judy and her son Justin beside him and brother Gary in back, as another summer comes to a close on "Beautiful Lake Orion." (Courtesy of the Grove family, photograph by Gina Grove-Strubbe.)